A GUIDE TO HISTORIC
Greenville
SOUTH CAROLINA

A GUIDE TO HISTORIC
Greenville
SOUTH CAROLINA

JOHN M. NOLAN
FOREWORD BY MAYOR KNOX WHITE

THE
History
PRESS

Published by The History Press
Charleston, SC 29403
www.historypress.net

Copyright © 2008 by John M. Nolan
All rights reserved

Cover design by Marshall Hudson.

All images courtesy of the author unless otherwise noted.

First published 2008
Second printing 2010
Third printing 2011
Fourth printing 2013

Manufactured in the United States

ISBN 978.1.59629.340.3

Library of Congress Cataloging-in-Publication Data

Nolan, John M.
A guide to historic Greenville, South Carolina / John M. Nolan.
p. cm.
Includes bibliographical references.
ISBN 978-1-59629-340-3
1. Historic sites--South Carolina--Greenville--Guidebooks. 2. Historic
buildings--South Carolina--Greenville--Guidebooks. 3. Architecture--
South Carolina--Greenville--Guidebooks. 4. Greenville (S.C.)--Buildings,
structures, etc.--Guidebooks. 5. Greenville (S.C.)--Tours. 6. Greenville
(S.C.)--History. I. Title.
F279.G79N65 2008
917.57'27--dc22
2008008691

Contents

Foreword

Historic places teach and inspire us, and Greenville has an abundance of architecture, sites and intriguing tales to share. Every era of Greenville's history is unique, beginning with Native Americans who fished and traded at Reedy River Falls, through its years of growth as the Textile Capital of the World to being the hometown of the inventor of the laser.

Early on, the city chose the path of commerce and industry in a region that was predominantly agricultural. After the devastation of the Civil War, we resumed our entrepreneurial ways and built a textile industry that by the twentieth century was a world leader. In the last half of the twentieth century, we took full advantage of our enviable location on the interstate highway system to attract diverse businesses, both national and international. Through this process, we literally reinvented our local economy and acquired world-class knowledge and skills. The city of Greenville has flourished to magnificent proportions.

What our forefathers could never have imagined is the extraordinary downtown environment, the rebirth of Reedy River Falls as the centerpiece of social activity, many beautiful neighborhoods supported by active, committed neighborhood associations, important growth industries and our ability to demonstrate innovation, leadership and superior service for the citizens of Greenville.

We are a confident community with deep roots that evolved over 175 years of going our own way. A confident community makes big plans and dares to be different. The city has raised the bar of quality in every detail, and in doing so we honor the better habits and traditions of our culture: faith, family, civility and community.

Mayor Knox White

Acknowledgements

First of all, I want to thank The History Press for the opportunity to write a book about the city I love, live and work in—Greenville, South Carolina. It is a place I am proud to call home. It's a great pleasure to live in a place that you want everyone to know about and experience.

The arrangement of the book is meant to be tourist- and visitor-friendly and at the same time serve as a practical reference for locals to learn more about their city. Because most of the information is site specific, it is impossible to give a thorough "history of Greenville." Instead, the reader can easily walk around town and get a deeper understanding of the stories and development behind the places of interest contributing to Greenville's vitality and charm. A number of books listed in the bibliography should be consulted for those who want to learn more.

Creating a guidebook that brings Greenville's sites alive and makes them relevant is an enjoyable task. However, it is one that takes a collaborative effort to bring in the right balance of stories, information and perspectives. I am especially grateful for the continual support and help of Greenville city officials, especially Mayor Knox White, his executive assistant Arlene Marcley and downtown development manager Mary Douglas Neal. For research assistance I am particularly grateful to the staff in the South Carolina Room in Greenville County's Hughes Main Library, including Durham Hunt, Cathy Jaeger, Steve Gailey and Susan Boyd. For the invaluable photographs I thank the Greenville County Library System and the Greenville County Historical Society. The City of Greenville graciously provided an attractive and accurate map. For their support I wish to also thank Rich Nelson, Bill and Angie Woodward, Tom and Bonnie Nolan and Skip and Maow Watson.

For researching information for this book, I have tried to consult much of the available primary and secondary sources and leave contested issues alone. I am greatly indebted to local historians Anne McCuen and Penny Forrester for their willingness to review the text and give invaluable criticism and comments. Others who provided helpful material and reviews of sections include Martha Severens, Ron Hamilton, Judy Isler, Phil Hughes, Lynn Duncan and Pam Meister.

The most significant help throughout this whole project has been from my wife, Anne. Without her patience, love and encouragement I could never have succeeded. She and my four children—Connor, Sawyer, Maddox and Olivia—are my daily joy.

Tour 1

The West End

A visit to Greenville around 1769 and a visit today would both likely start in the West End near the waterfall—the social and recreational center of the city. Only a handful of cities in America can boast a glorious waterfall at the center of their downtown. When Greenville's first colonial settler, Richard Pearis, decided to put his home here, the waterfall played a primary role in his decision and continues to attract more people to this city even today. The West End tells the story of Greenville's growth and success perhaps better than any other place in town, from its inception as a trading post and grain mill center to one of the most flourishing revitalizations in the Southeast.

Greenville's risk takers and entrepreneurs have fueled the city's development throughout its history, and its first colonial resident was no exception. Richard Pearis came to upper South Carolina as an Indian trader around 1754 after dissolving his Holston River trading business with Nathaniel Gist. He was in and out of South Carolina over the next few years, but eventually settled in present-day Greenville about 1769. At the time of his settlement, this area of the Upstate was still made up of virgin forest and plains, reserved as hunting lands for the Cherokee and Catawba tribes by the Treaty of Fort Prince George in 1761. Pearis established his plantation, Great Plains, after returning from duties in the French and Indian War.

Pearis knew he risked everything by settling here. When he built his home the land was still restricted to Indian use. After living for several years in peace, he was arrested and taken to the town of Ninety Six in violation of the law. There he concocted a plan that could get him out of trouble. In Charles Town, Richard persuaded some Cherokee chiefs to sell his half-Indian son, George, 150,000 acres in the Upstate. Indians could legally sell land to other Indians. George then went to England, became

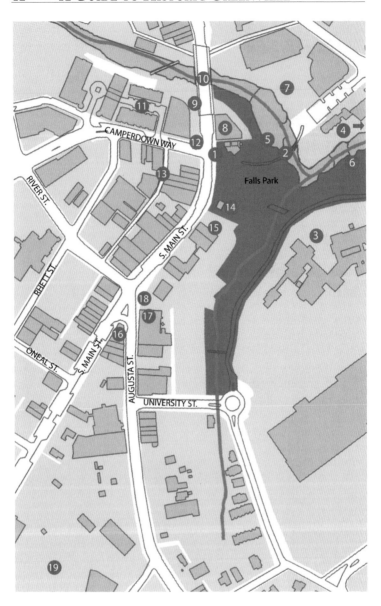

Tour 1: The West End. *Courtesy of the City of Greenville.*

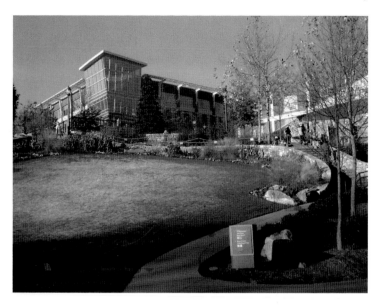

View of Falls Park with Riverplace in the distance—both of these West End destinations are popular draws for visitors.

a British citizen, returned to South Carolina and sold his father the majority of his land. This could happen because British people could legally sell land to other British people. Pearis was now free to live at Great Plains, successfully establishing a trading post and a gristmill along the banks of the upper falls.

In the late 1700s and early 1800s, farms dotted the landscape around the wagon road that came from the mountains into the heart of the village, through the West End and on to Augusta. Commercial development grew in the 1830s, shortly after Vardry McBee's recently built gristmills at the edge of the waterfall brought more interest to the area. When the railroad first connected to Greenville in 1853, its depot was located just down the road on Augusta Street near the present-day baseball stadium. Activity picked up soon after, as goods could now quickly and efficiently move in and out of the city. More people had a reason to stay, too, with the establishment of Furman's campus in 1852 and the building of the Greenville Hotel on the corner of University and Augusta Streets soon afterward.

Just as the West End started to flourish, the Civil War took away the men—many of them students and faculty at Furman—to fight for the cause. Some of them might have felt nostalgic about home as they came into contact with vital homemade items used throughout the South—Morse carbine rifles made in the State Military Works or the war caissons and wagons made at the Gower, Cox and Markley Carriage Factory.

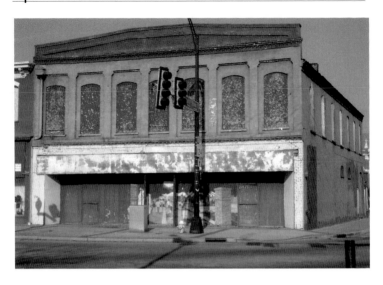

On the corner of Main and River Streets, Clyde and Hovey's Dry Goods Store was built circa 1869 and was the oldest extant retail building in Greenville. It was demolished in 2010.

One of the notable postwar buildings still standing (and the oldest building still surviving on Main Street) is the green brick building on the corner of Main and River Streets. It was originally Clyde and Hovey's Dry Goods store, where people on the West End came to get their everyday food, clothing and tool products. Stores continued to be built radiating out from the intersection, especially evident in the row of 1880–90 two-story brick buildings still standing to the left of Clyde and Hovey's. These buildings have been renovated one by one over the last few years, returning their original character to enhance the experience of patrons over 120 years after they were built. Today the West End is a thriving part of the downtown Greenville experience. Whether it's the waterfall, the great restaurants, festivals, baseball games, shopping or simply its charm, the West End will keep you coming back.

1. Falls Park Entrance

Many of Greenville's public spaces are adorned with a wonderful blend of both natural and man-made works of art. From the intersection at South Main Street and Camperdown Way, Bryan Hunt's unique sculpture of *Fall Lake Falls* draws many curious passersby to stop, look and sometimes cool their hands in the water that flows smoothly along its granite base. This attractive entrance, surrounded by a semicircle of smaller water features

sheathed in rustic rock walls, is simply an introduction to one of the most amazing sensory experiences you will have in the city—or the South for that matter. As you walk down the steps and get a bird's-eye view of the park, the first word out of most first-time visitors' mouths is "Wow!" The deep ravine is not a Grand Canyon experience, but the sense of beauty you feel as you take in the sights from the top of the slope going into the park will inevitably create a memorable experience. To the right you'll see the gorgeous terraced gardens interlaced with rustic brick pathways, stone walls and an open-air amphitheater.

The entrance to Falls Park draws people in with its scenic fountains and Bryan Hunt's unique sculpture called *Fall Lake Falls*.

How did the park get so beautiful? It started with the vision of some locals who wanted to bring it back to its rightful position as the crown jewel of the city. The Carolina Foothills Garden Club began their mission to revitalize the park in 1967 and started a massive cleanup and planting campaign. Local businesses, volunteers, city officials and Furman University all

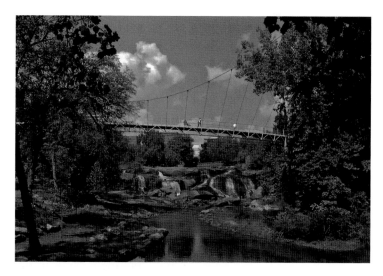

Greenville's forty-foot waterfall is a unique natural treasure. Few American cities can boast of such a feature in their downtown.

came together to provide the vision, funds and hard work to make this dream a reality.

The last phase of beautification began in 1990, when the city hired Washington, D.C. landscape architect Andrea Mains to design and organize the plan of pathways, gardens and hardscapes. With a project budget of just over $13 million, Falls Park has developed into the social hub of the city for locals and tourists alike. Greenville's booming restaurant and hotel business has largely funded the project through the city's hospitality tax funds.

2. Liberty Bridge

The building of the Liberty Bridge was a momentous occasion in the history of Greenville. The former Camperdown Road Bridge was torn down in 2003 and the new Liberty pedestrian bridge was dedicated in September 2004. The name of the bridge honors the Liberty Corporation—one of the city's great homegrown business success stories—which purchased the naming rights. When the road bridge was built in 1960, it completely covered and obscured the view of Greenville's best natural asset—the Reedy River waterfall. Why? By the second half of the century the Reedy had become so polluted and foul smelling that locals no longer enjoyed the falls for recreation. In the late 1800s the river was claimed as a power source for the Camperdown Mills along the banks of the upper and lower falls. The "Rainbow Reedy," as it had been pejoratively

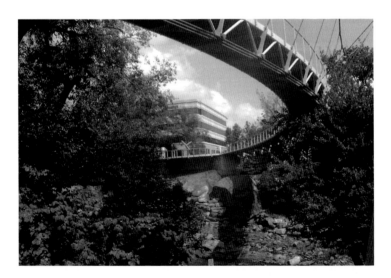

Liberty Bridge provides a spectacular overlook of the Reedy River Falls.

named, was tainted with dyes dumped in from mills upstream, in addition to storm and sewer runoff. Subsequent generations of Greenvillians scarcely had reason to go downtown, let alone notice there was a waterfall located there.

As the revitalization of Falls Park reached its fruition in the early 2000s, the Camperdown Bridge became an eyesore that had to be taken down. A competition was held to design Greenville's new pedestrian bridge that would, as a byproduct, determine the city's primary icon for the future. Renowned Boston architect Miguel Rosales won the commission and designed a unique bridge unlike any other in the United States. It was built for $4.5 million and has been embraced by all as the crowning embellishment to the Falls Park experience. What sets this bridge apart from others is the single cable suspension system spanning its length and supporting the weight on the side away from the view of the falls. This unique arrangement allows the deck to seem to float in the air. In fact, with enough people walking on the bridge you will feel it move up to several inches up and down because the walkway platform is only eight inches thick! If that seems too unstable for you, it may give you comfort to know that the two ninety-foot masts holding up the bridge weigh twenty-eight tons apiece and are anchored seventy feet into the bedrock.

In 2005, the Liberty Bridge won the prestigious Arthur G. Hayden Medal for outstanding achievement in bridge engineering (provided by Schlaich Bergermann) at the International Bridge Conference. While this award-winning bridge is a recent ornament in Greenville's history, it promises to be an enduring fixture to its beautiful landscape.

3. Furman University's Original Greenville Campus

The namesake of Furman University is Dr. Richard Furman, whose work in promoting education was crucial to the institution's organization. In the early 1800s, he served as pastor of First Baptist Church of Charleston for thirty-eight years and was instrumental in organizing Baptists statewide with the establishment of the South Carolina Baptist Convention. The convention honored the recently deceased Richard Furman by naming the denomination's new ministerial school Furman Academy and Theological Institution. It was chartered in 1826 and held its first classes on January 15, 1827, in Edgefield, South Carolina. Scant enrollment and financial hardship caused the school to relocate to the High Hills of Santee from 1829 to 1834. After another move to Winnsboro, South Carolina, the convention decided in 1850 to make the school's final move to Greenville, South Carolina.

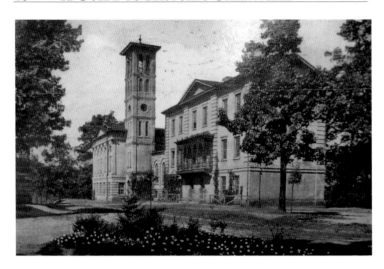

Furman University's original Greenville campus with its distinctive Italianate bell tower stood on the hill overlooking the majestic Reedy River Falls. *Courtesy of the Greenville County Library System.*

Once in Greenville, trustees decided to make Furman a liberal arts school and renamed it Furman University. Important elements in the school's decision to choose Greenville were its favorable climate, population growth and the city's commitment to bring in a railroad line. The city's leading businessman and landowner, Vardry McBee, played a primary role in helping Furman establish itself in Greenville. Classes initially met in the heart of downtown at McBee Hall on the northwest corner of McBee Avenue and Main Street. More importantly, McBee worked out a deal to sell the school some of the city's best real estate on top of the hill overlooking the Reedy River Falls. He sold the land to them for $7,500—a fraction of the cost he could have received for the land from other interested buyers.

In 1852, work commenced on building Furman University's campus, with designs by noted Charleston architect Edward C. Jones, who had recently gained acclaim with his design of Westminster Presbyterian Church in his hometown. Jones was also designing Wofford College's Old Main as well as the Colonel John Algernon Sydney Ashe House on Charleston's Battery at the time Furman was being built. Furman's first campus building was known as Old Main (later Richard Furman Hall). The building's classical design included a large central pediment, rectangular windows and an iron-canopied balcony spanning one-third of the second story. In the left center of the complex a beautiful Italianate bell tower soared eighty-eight feet into the air and has remained the university's most enduring symbol. Students went from "rags to riches" when the classes were finally held in Jones's gorgeous new

complex in 1854. For two years prior they had been meeting in a couple of simple wooden schoolhouses. One of these still survives and was moved to the university's new campus in 1959.

After nearly closing as a result of the devastating effects of the Civil War, the campus greatly expanded in the late nineteenth and early twentieth centuries (by 1911 Greenville was boasting itself as the educational center of the state). Of particular note was the domed Judson Alumni Hall, built in 1900 to provide a large auditorium for chapel services. The handsome Andrew Carnegie Library was built in 1907 with matching funds from the Carnegie Foundation.

Albert Einstein, author of the special and general theories of relativity and Nobel Prize winner, visited Furman's downtown campus several times in the late 1930s and early 1940s while visiting his son, Hans. Hans Albert Einstein moved to Greenville in 1938 to work with the government's Soil Conservation Service. Einstein visited regularly for about three years and would take walks on Park Avenue and Atwood (behind Greenville Women's College) near where his son lived. Furman classes were cancelled when Albert Einstein visited and all came to hear him speak in Judson Alumni Hall.

In 1933, the struggling Greenville Women's College (founded in 1854 as Greenville's second oldest school of higher learning) merged with Furman University, but remained on its College Street campus. The unification of Furman with Greenville Women's College, a postwar rise in enrollment and a rapidly aging campus caused trustees to purchase nearly one thousand acres of farmland on the outskirts of the city in 1950. Construction of the new Colonial-style campus commenced over the next decade, with the Greenville Women's College's final merge to the Poinsett Highway campus in 1961. After Furman vacated its original West End location, the historic buildings were eventually torn down. The Italianate tower that called students to class for over a century was the only structure saved—destined to become the mascot of the new bell tower mall built on the site. The mall never took off and the shopping center was bought by the county and converted into the Greenville County office complex. A full-scale replica of the original campus bell tower was constructed in 1964 on a man-made peninsula in the lake on Furman's present campus. The South Carolina Governor's School for the Arts also now resides on the old Furman campus.

Some of Furman's most notable graduates include Charles H. Townes, Nobel Prize winner (1964) for his invention of the maser and also the laser; John Broadus Watson, founder of behavioral psychology; Charles Matthews Manly, early American aviator and inventor; Sam Wyche, NFL head coach; Keith Lockhart,

Boston Pops conductor; and Dick Riley, two-term governor of South Carolina and U.S. secretary of education under President Bill Clinton's administration.

4. Major Rudolf Anderson Jr. Memorial

Rudolf Anderson Jr. was born on September 15, 1927, and graduated from Greenville High School in 1944. He grew up at a time when Greenville was king of the textile industry, which influenced his decision to attend Clemson Agricultural College and earn a bachelor's of science degree in textile engineering. Anderson was involved in the Air Force ROTC while at Clemson and it is there that his patriotic sense was nurtured. Three years after graduating he was compelled to leave his work in the textile industry and enlist in the U.S. Air Force to serve in the Korean War. Anderson saw plenty of combat action in Korea flying F-86 Saber jets. By the end of the war, he was awarded a Distinguished Flying Cross for his contributions. During the ensuing years he trained as a U-2 spy plane pilot for high-altitude reconnaissance flights and participated in numerous top secret Cold War missions over communist China and the Soviet Union.

Anderson's most important call of duty came in October 1962 after the CIA informed President John F. Kennedy that Fidel Castro was arming Cuba with what appeared to be medium-

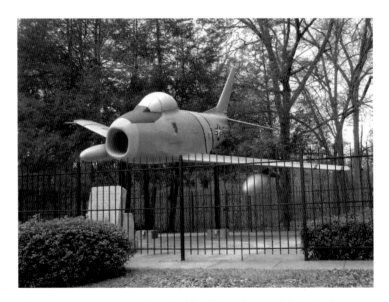

The airplane memorial in Cleveland Park is a tribute to Major Rudy Anderson, a U-2 spy plane pilot and Greenville native who was the only person to die in the Cuban missile crisis.

range ballistic missiles imported from the Soviet Union. The U.S. Air Force sent its top U-2 pilots to gain the photographic proof of the missiles and Rudy Anderson was chosen for this highly dangerous mission. Enough evidence was obtained in the initial flights to confirm that offensive nuclear missiles were aimed at the United States. As more pilots and aircraft were summoned for missions, Anderson volunteered for flights over and above the routine rotation.

Tensions came to the crisis stage when Kennedy ordered an ocean blockade to keep Soviet ships from entering Cuba and informed the American people of Khrushchev's reckless actions. As war seemed imminent on the twelfth day of the Cuban missile crisis (October 27, 1962), Rudy Anderson's U-2 spy plane was shot down over Cuba and he was killed. With this American casualty, Kennedy was advised to attack Cuba but Khrushchev backed down after last-minute negotiations. The war was avoided and Greenvillian Rudy Anderson was the sole death amidst America's nearest moment to nuclear conflict. A month later President Kennedy visited U-2 pilots at Homestead Air Force Base in Florida and said that the nation is "particularly indebted" to Major Anderson. Many historians believe it was his death that contributed most to the chain of events averting World War III.

The F-86 Saber jet featured in the memorial commemorates Rudy Anderson's life and sacrifice with an aircraft similar to the ones he flew in the Korean War. It was dedicated on May 19, 1963, less than a year after his body was finally returned by Cuba and buried at Woodlawn Memorial Park. An appropriate scripture passage is engraved in the memorial stone: "Greater love hath no man than this, that a man lay down his life for his friends." (John 15:13)

5. Vardry McBee's Mills

Along the left side of the falls, you may easily miss the rustic, eroded brick and stone wall next to the walking path. Because so much stone is used throughout the walkways and walls in Falls Park, there is an "old" feel to the overall look. However, the stone and brick behind the "Vardry McBee Mill" historical marker are the oldest ruins found in downtown Greenville. A two-story flour gristmill built in 1816 used to sit on top of the foundation wall that remains today. Gristmills ("grist" means grain) were an important component of village life in colonial America. People could not go to the local grocery store and pick up all of the conveniences we enjoy today. Grains, meat, fruit and vegetables were the staples of their society and they had to prepare each of their meals from scratch. Gristmills were

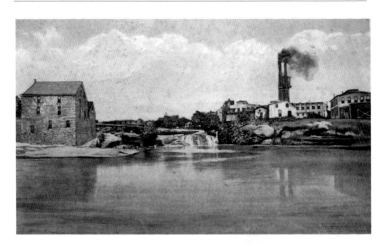

Vardry McBee's old gristmills are seen here on the west (left) bank of the Reedy River Falls. *Courtesy of the Greenville County Library System.*

one of the conveniences that allowed them to get processed grains to make cooking a little easier. Customers or suppliers would bring grain already removed from the stalk. The 1816 mill was powered by water flowing down the Reedy River to a wooden race that channeled water over to the mill. The volume of water coming to the mill was aided by the stopping up of water behind a shallow dam on top of the falls. Its two small water wheels utilized the fast moving water to push the paddles on the wheels. The wheels then turned gears in the lower floor to a pair of large millstones crushing the raw grains into fine flour on the second floor. The lower stone was fixed in place and was called a bed. The upper stone turned and was called the runner. Grooves were cut into the runner stone to provide greater friction and remove the outer husks, allowing the grain to flow out of the pressed stones. Grain was then stored in the top floor of the mills.

McBee's mill was one of the first business ventures he started after purchasing nearly the entire town (11,028 acres) of Greenville a year earlier in 1815 from Lemuel Alston. He wisely chose a business that would fill the need of a growing village. This first mill was so successful that McBee added another larger corn mill right next to it (to the left) in 1829 powered by one large water wheel. These and other local mills provided villagers from Greenville and the surrounding areas with the means to have a steady and reliable supply of grain. In the latter decades of the nineteenth century, the 1816 mill was refitted as a machine shop. When the 1829 mill had long been out of service and was demolished in 1919, its massive wall stones were used to build the Neo-Gothic crenellated tower of the three-story Gassaway

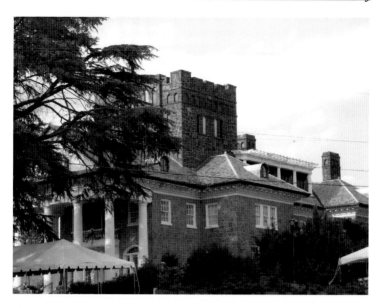

The Gassaway Mansion, called Isaqueena, was finished in 1924 and was later used as the first home of the Greenville County Museum of Art.

Mansion at 109 Dupont Drive just off East North Street. The eclectic architecture is set off by six massive Doric columns and a Neoclassical portico. The building is on the National Register of Historic Places and remains one of the most unique and impressive private homes in the city today.

6. Camperdown Mill No. 1

Greenville County had a handful of startup textile mills prior to the Civil War, but not enough to make a significant contribution to the overall local economy. The nearby Batesville mill and a few others supplied enough raw materials for locals so that they didn't have to wait for imports from New England for their needs. After the Civil War, businessmen turned to the river to help rebuild their economy with textiles. The first mill in the city of Greenville to locate on the river was the Sampson & Hall Mill in 1874, leased from Vardry A. and Alexander McBee (sons of Vardry McBee) to Oscar Sampson, George Hall and George Putnam. These Massachusetts businessmen came to the Upstate looking for a new start in the South after their cotton commission business burned in Boston's great fire of 1872. They came to an area that was still recovering from the Civil War and had little precedence in textile production. However, because of their experience in the cotton industry, they looked to start a

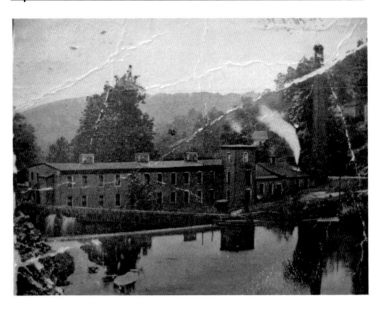

The Camperdown No. 1/Vardry Mill is shown in this tattered postcard, seen from the Main Street Bridge. *Courtesy of the Greenville County Library System.*

textile mill. The first mill built was located just below the lower falls in what is now Falls Park. A mill village housing the more than fifty employees soon grew up in the area surrounding the mill along the slopes of the hill and east toward Falls Street. Just as the earlier gristmills had dams and water sluices to shuttle the water to their water wheels, so did the first textile mills in the city. A pair of large water wheels turned a shaft that powered the machinery inside. Ruins of the water wheel housing still remain in the park as a reminder of this once thriving mill.

According to Ray Belcher, the Camperdown Mills failed in 1885 and was reorganized as Camperdown Cotton Mills under the leadership of successful Piedmont Manufacturing owner Henry Hammett. However, the mill continued to struggle and closed in 1894. Oscar Sampson bought the machinery and moved it out the next year to use in his new textile venture called the Sampson Mill located off Buncombe Road. Downtown Greenville's first mill was resurrected in 1906 when Luther McBee began operations. He renamed the business Vardry Cotton Mills and hired seventy-five operatives to produce coarse yarn products.

By 1923 the Vardry Mill closed for good and was soon used as a storage building for Furman University on the hill above. In 1943, the mill burned down and the cause of the fire was never solved by authorities. However, local historian Richard Sawyer was giving a tour of the park in recent years and told

the history of the Vardry Mill with its mysterious demise. One of the men on the tour said that when he was young, he and his friends had a secret clubhouse in the old mill and were having a meeting. They forgot to blow out a candle after leaving and the mill, laden with flammable paper products, easily caught fire. Today ruins of the lower walls, wheelhouse structure and foundation remain in the park.

7. Camperdown Mill No. 2

The successful outlook of Sampson and Hall's first mill caused a new joint stockholding venture to build another mill (225 by 64 feet) on the eastern bank of the upper falls. The 1874 mill across the river was renamed the Camperdown Mill No. 1 and the new mill opened in March 1876 as the Camperdown Mill No. 2. Like its gristmill predecessors, Camperdown No. 2 started out as a water-powered mill with a dam and water sluice. If you look along the cliff at the side of the waterfall today, you will see two partial pillars of brick that were once the foundations for the mill's water tower.

After six years, the Camperdown Mill's business was booming and employed several hundred operatives. Success was short-lived, however, as the mill went under in 1885 and was soon reorganized by Henry Hammett, the most successful mill owner in late nineteenth-century Greenville. He renamed the mill the Camperdown Cotton Mills, but its resurrection lasted less than a decade. The large mill was not used for several years at the end of the nineteenth century, but resumed operation again in

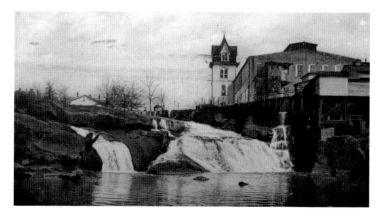

Camperdown No. 2, the city's second textile mill, stood on the eastern bank of the Reedy River Falls for eighty-three years before its demolition in 1959. *Courtesy of the Greenville County Library System.*

early 1901 to the cheers of locals who had hopes that it would fuel the economy once again. Twentieth-century products of the mill included finished gingham and plaid fabrics similar to the nearby Huguenot Mill. When the mill reopened, a total of eight mills were then in operation within a two-mile radius of the city employing thousands of men, women and children.

Camperdown No. 2 continued to struggle prior to World War II and went bankrupt in 1930. Despite its ups and downs of success over the years, Batesville Mill President Mary Putnam Gridley said in 1929 that the "Camperdown Mill and the running to Greenville of the Seaboard Airline Railway track put the town on its feet and started it climbing to the pinnacle it has now achieved, the manufacturing centers of South Carolina." By the 1950s the mill could not keep up with cheap competition from Japanese makers. Its doors closed for the last time in 1956 and left 275 workers without jobs. The mill was finally demolished in 1959 and locals mourned when the distinctive old tower (which stubbornly took two days to tear down) no longer graced the skyline. Remnants of the mill likely endure today in other local structures as contractors, carpenters and "do-it-yourselfers" salvaged the bricks and lumber for other projects. The property was bought by Citizens and Southern Bank in order to build its modern regional headquarters on the picturesque site. Within a few years the Camperdown Bridge was built over the falls and dozens of Camperdown Mill village homes were torn down to make way for the Church Street extension project. The bank was torn down in 1991 and a newer building was erected as the home of another headquarters—specialty paper and newsprint giant, Bowater (now AbitibiBowater).

8. Cotton Warehouse

The oddly shaped five-sided building bordering the upper falls west bank on one side and Main Street on the other was built by Davis Furman and Walter Gassaway in 1913 as a cotton warehouse. Cotton was in constant demand to supply the daily workload of the three mills across the river, as well as dozens outside the city limits. This large building was in a convenient location to receive incoming loads from the railroad and Main Street. It was among the early fireproof cotton warehouses built in the city, which is why it is still standing today. So many of the earlier cotton warehouses had burned down because of their flammability, but this has stood the test of time and is nearly a century old. The bricks toward the top of the structure are more weathered than those on the lower floors and betray its age more clearly. Coca-Cola Bottling Co. occupied two floors in the northern half of the building, while Crescent Grocery provided

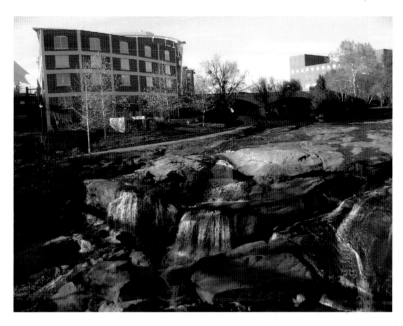

The restored Falls Place building overlooks the Reedy River Falls. *Courtesy of the Greenville County Library System.*

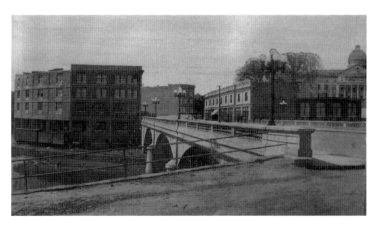

Falls Place is seen on the left in its early twentieth-century days as a cotton warehouse. All of the buildings on the right side of the Main Street Bridge are now gone. *Courtesy of the Greenville County Library System.*

West Enders with readily available food in its new location. Meador's Manufacturing Company later occupied the building.

After the Greenville Army Air Base reopened as Donaldson Air Force Base in 1948, the old warehouse was soon used as a USO headquarters, drawing hundreds of soldiers into the West End. The building now known as Falls Place (once called the

Traxler Building for owner David Traxler) underwent extensive renovation in 1985 and is one of the charming old buildings still gracing the streets of the West End.

9. McBee Millstone

Stonework abounds in the Falls Park area and thousands of people daily go by a special stone that blends in with the rest. Little do they know that it holds a unique position in Greenville's history. Underneath the Main Street Bridge is a circular millstone from one of the old gristmills that graced the banks of the Reedy River Falls. In the last decade of the twentieth century, members of the city's Parks and Recreation Department discovered the stone during a particularly low water level period in the vicinity of the lower falls. In all likelihood this millstone came from Vardry McBee's gristmill that was converted to use as Sampson & Hall's textile mill. The January 9, 1874 contract between the McBees and Sampson and Hall stipulated that the McBees would remove the old millstones and grinding equipment from the gristmill before it was converted into a textile mill. A few other gristmills were located in this area, but records are sparse and McBee's is the only one mentioned to be retrofitted with the grain machinery removed.

The stone probably dates to the mid-1800s and could even be a salvaged stone used from Richard Pearis's gristmill from the late 1700s. After it was extracted from the river, it was on

The millstone underneath the Main Street Bridge was recovered from the Reedy River and is likely from Vardry McBee's gristmill.

display for several years at the entrance to Falls Park, where Bryan Hunt's *Fall Lake Falls* sculpture now resides. It was moved under the bridge to its current out-of-the-way location when Hunt's sculpture was installed. Cement has been filled into the central hole where a large wooden beam would have originally gone through to turn the massive stone to grind the grains into flour. The cut grooves in the surface of the diameter betray that it was used as the runner stone to help remove the outer husks and also allow the grain to flow out while grinding. They are a faint reminder of the decades this stone was in service to the people of this city and region. This granite stone may be one of the oldest known artifacts from Greenville's early history.

10. Gower Main Street Bridge

The walkway from the Reedy River Falls brings you to the Gower Bridge on Main Street. The bridge's namesake is Thomas C. Gower, an ambitious man who migrated from Maine to Greenville in 1842. He sought a position in his brother's coach factory on the northern bank of the Reedy River. Immediately next to the factory was a rickety wooden footbridge that crossed the ford at Greenville's Main Street. Gower had firsthand experience of seeing the problems the bridge caused daily for businesses and pedestrians alike. After barely weathering the economic ruin brought on by the Civil War, this well-respected businessman ran for mayor of Greenville in 1870 with a platform that consisted primarily of putting the first substantial bridge across the river. A large opposition, including the incumbent mayor, was against

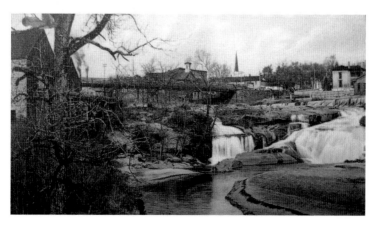

The 1890 iron Main Street Bridge is seen in the background of this view of Reedy River Falls. *Courtesy of the Greenville County Library System.*

the plan because of the large expense for taxpayers. Gower won the mayoral race, city council voted to fund $1,500 and work began on the new wooden bridge. T.C. Gower's other significant contribution to Greenville's transportation was his startup of the first streetcar system in 1875.

A second, stronger structure came in 1890 when an iron bridge was erected by the Southern Bridge Co. to meet the needs of a growing city and a new generation. Horse and carriage was still the primary means of transportation when the bridge was finished and there were rules for their use on the bridge. A few years after cars began to appear in town, Greenvillians caught riding their horses across the bridge instead of walking them could be fined five dollars. By the end of the first decade of the twentieth century, even the iron bridge would be insufficient for the heavier weights and wear of cars. Like its predecessor, the iron bridge also lasted twenty years before having to be replaced. What spans the river now is the third substantial bridge across the river on Main Street. It was constructed of concrete by J.E. Sirrine in 1910. A year later, Greenville County had three hundred car owners and Main Street was completely paved. Three years later the number increased to just over one thousand—more than any county in South Carolina. This concrete bridge has lasted nearly a century, servicing Greenville's ever-increasing traffic. In 2000, the bridge received a full restoration and was rededicated as the Gower Bridge in honor of the man whose vision lives on today in the spirit of many of Greenville's current entrepreneurs.

11. Riverplace

For more than half of Greenville's history the "river walk" land between Riverplace and the Reedy was gently sloping grassland leading up to McBee's Terrace on the hill. In the last decade of the nineteenth century, Greenville's railroad was expanding, with a new line connecting Greenville to Asheville. A track was built across the Reedy River (whose foundations form part of the current dam near the Main Street Bridge) and ran along the southern bank of the river where the Riverplace complex now resides. The track extended to Potts' Cove in the foothills of the Blue Ridge Mountains, but never reached its intended destination of Asheville. The line of the old "Swamp Rabbit" railroad, as it was called, is mimicked today in the painted tracks on the sidewalk running in front of the tiered water feature and the train façade (complete with a light) going through the "tunnel" painted under the stairway.

In the first decade of the twentieth century R.E. Allen & Bro. Co., Inc. built a 50- by 150-foot, two-story brick warehouse for

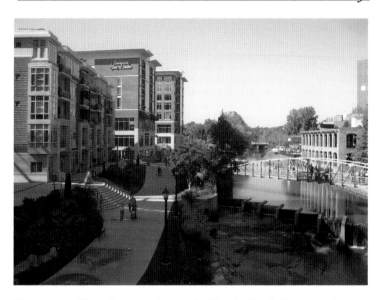

The gorgeous Riverplace complex overlooking the Reedy River was the first significant construction project in the West End's twenty-first-century revitalization.

its wholesale grocery business. Imported and domestic groceries filled the building and were easily shipped in and out on the railroad track just outside its doors, which faced the river. The firm, opened in 1884, was a fixture in the city by this time. The same warehouse became a cotton warehouse before being taken over by Southern Handkerchief Co. by 1948. The lot is now occupied by the first building of the $150 million Riverplace complex. The angular glass and steel corners that project out beyond the main building give the structure a distinctly modern flair. The 87,000-square-foot mixed-use building broke the mold of Greenville architecture, bringing it firmly into the twenty-first century. However, the overall look of the red brickwork, cement striping motifs and curved façade temper the effect to blend in with the century-old cotton warehouse across the street. The first Starbuck's coffee shop in downtown Greenville was among the original tenants, followed by the popular High Cotton Restaurant—a successful Charleston restaurant whose first expansion out of its hometown is Riverplace. Michelin on Main's historic opening in the autumn of 2007 represents the tire giant's first retail store of this kind in North America. The glass mezzanine, technological design features and hanging automobile are elements of this store you won't want to miss.

The next pair of buildings comprises four- and five-story condominiums that once stood on an area occupied by various residences. When Riverplace was being built, living in downtown

Greenville was still a relatively new concept. These condos had something that had never been offered in the downtown business district—residential rooms with a direct aerial view of the Reedy River. Another amenity in this section of Riverplace is found on the river level. The parking garage was initially intended to fill the entire sublevel floor. However, the developer and city worked together to do something special—create a series of working artists' studios called Art Crossing. Instead of just more parking, people can now enter the studios of painters, ceramists, sculptors, photographers and more to buy work from the artists themselves.

The next section is occupied by Hampton Inn and Suites, Lazy Goat restaurant, retail and the breathtaking four-tiered water feature that rises about twenty-five feet high. The next phase on the other side of the fountain is more mixed-use office, condo, retail and restaurant space. The final phase of Riverplace will continue up river and occupy part of the land that was Jacob Cagle's lumber mill for many years in the late 1800s.

Riverplace was the brainchild of local developers Bob and Phil Hughes. It has been a key factor in the revitalization of downtown Greenville and, specifically, the West End. It represents the largest private investment in Greenville history at the time it was built.

12. Charles Townes Statue

Unless you're a local interested in history or work in the field of physics, most likely you've never heard of Charles H. Townes, the man depicted in this bronze statue. However, unless you're from Mars, you've certainly heard of his invention, the laser. The work of Charles Townes has reached and influenced millions of lives throughout the world—more than any other native in Greenville's history. Charles grew up on a farm in rural Greenville, attended Greenville High School and went on to graduate with a degree in physics and language from Furman University (then still located on its original campus overlooking the Reedy River Falls) in 1935. Townes began his quest to research microwaves and molecules at Columbia University, leading to his development of the laser's predecessor—the maser. "Maser" is an acronym for **m**icrowave **a**mplification by **s**timulated **e**mission of **r**adiation. He later applied this field of inquiry into the optical and infrared realm, leading to the development (in 1960) of the laser—acronym for **l**ight **a**mplification by **s**timulated **e**mission of **r**adiation. The groundbreaking research and developments behind these two inventions are the reason Townes was awarded the Nobel Prize in Physics in 1964.

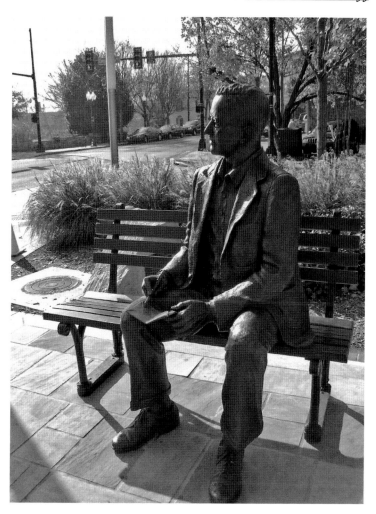

Greenville native Charles H. Townes is the inventor of the laser—one of the greatest inventions of the modern age.

The background of the scene represented in the statue is when Townes was attending the last meeting of a naval committee in Washington, D.C., which was trying to figure out how to attain the shortest wavelengths for microwaves. Research results remained disappointing to the members, so Charles woke up early one morning and took a walk in Franklin Square Park to clear his head and think about the project. His "eureka" moment for harnessing beams of molecules came while sitting on a bench, and he scrawled the original formula for the maser on an envelope from his pocket.

An interesting tie to this momentous occasion is the ironwork holding up this statue. It is from an original bench from Franklin Square Park, where Townes made his discovery. Phil Hughes,

who helped finance the creation of this statue, called the Parks and Recreation Department in Washington, D.C., to see if they could obtain an original bench from the park. Officials said they happened to have a few left after recently replacing all of the old ones.

While inventing the laser and winning the Nobel Prize is enough life's accomplishment for anyone, Townes has achieved a number of other notable distinctions in the field of space. He and his assistants were the first to discover complex molecules in space. He also pioneered the first calculation of mass of the black hole in the center of the Milky Way. Furthermore, when President John F. Kennedy committed America to be the first to put a man on the moon, Townes was appointed chairman of his Science Advisory Committee. Charles Townes's contributions to civilization have caused him to be voted one of the most influential one thousand people of the twentieth century.

Commemorating Charles Townes's invention of the laser serves as an inspiration to any who will dare to dream, work hard and take educated risks with their ideas. Now visitors can know that a Greenville native is behind the technology in CDs and DVDs, laser eye surgeries, precision welding and drilling, weapon targeting, cancer treatments and various communication systems, to name a few. If you look closely, a green light representing a laser shines out of the pen that Townes is holding.

13. Chicora College

Few who stroll near the corner of Camperdown Way and South Main realize that a huge classical building used to majestically overlook the Reedy River there. The site was known as McBee Terrace in the mid-nineteenth century, named because it was the property of Alexander McBee (Vardry McBee's son), who had a farmhouse on the site before Chicora came. The word "chicora" is an Indian term with original colonial use in the South Carolina coastal area meaning "the land," but also said to mean "Carolina" in Cherokee.

Chicora was the last of four colleges (five including A.S. Towne's offshoot from the Greenville Female College) to open in Greenville by the end of the nineteenth century. Chicora College for Young Ladies began classes on September 30, 1893, on McBee Avenue. Meanwhile, the imposing main campus—including a girls' dorm, administration building, classroom building and a central octagonal auditorium big enough to seat 1,200—was under construction. In the early 1900s the auditorium was capped by a massive dome, making the overall building reminiscent of the Capitol Building in Washington,

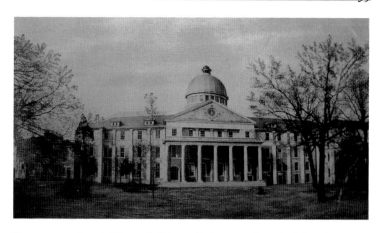

The commanding building of Chicora College stood on the hill at the corner of Camperdown Way and South Main Street for a quarter century before burning down in 1919. *Courtesy of the Greenville County Library System.*

D.C. Forty years earlier, Furman had located in the West End overlooking the Reedy and attracted male Baptists to its doors (Furman controversially became coeducational in the years before 1900, though it initially drew low female numbers). The new college attracted a niche of Presbyterian women, especially convenient to those who lived in the growing neighborhoods on Augusta and Pendleton Streets. Curriculum included such offerings as Bible, natural science, mathematics, physics, language, voice, bookkeeping and art classes. For activity, the campus tennis court was one of the girls' favorite pastimes.

Low enrollment plagued Chicora throughout its early years. After the first decade of the new century, enrollment had increased but competition from Greenville Female College (whose enrollment was almost twice as high as Chicora's) and financial woes caused the all-female school to fall short of the trustees' initial expectations. They decided to move the college in 1915 and took over their recently closed sister institution, (Presbyterian) College for Women in Columbia. Chicora later merged with Queens College and continues today as Queens University of Charlotte.

When the college vacated, its gorgeous empty building stood perched on a prime piece of real estate. Businessman C.C. Good saw the potential and bought the property, opening the Colonial Moving Picture Theater in the central domed section of the building. Dorms and classrooms in the wings were converted into the Colonial Apartments. Four years after the college left for Columbia, the building burned down in what some say was the worst fire in Greenville's history. Flames fueled by high winds were so intense that a house on Falls Street, all the way across the Reedy River, caught fire. The lack of proper

fire equipment to bring the disaster under control caused a local uproar. At the conclusion of a town meeting about the matter, citizens demanded either a purchase order for new equipment within sixty hours or else the resignations of members of city council and the fire commissioners. Local historian Richard Sawyer relates that several of the massive Ionic columns from Chicora's portico were discovered in the late twentieth century in the pooled water below the falls, fished out and mounted on nearby pedestals, only to be later ruined by vandals.

A year after the fire, the present series of cream-colored brick stores bordering South Main Street was built and soon served tenants connected to the automobile craze of the 1920s. These same buildings (minus the corner structure, now a parking lot) house the restaurants and retail stores that have helped make the West End so attractive for people to visit today.

14. Touchstone House

One of the most charming buildings still surviving in the West End business district is the home found on the bend of South Main Street called the Touchstone house. The two-story stucco-covered brick house overlooking the Reedy River Falls was built in the last decade of the nineteenth century by W.E. Touchstone and his wife Matilda shortly after Chicora College was built across the street. Touchstone was the supervisor of the Camperdown

The late nineteenth-century home of W.E. Touchstone is now called Falls Cottage and houses one of downtown's most charming restaurants.

Mill across the river, so the home's location was very convenient. The majority of other Camperdown workers lived in the mill village housing off Falls Street. Camperdown Mill closed just as his home was built and he moved to Alabama while his family stayed in the home for three more years. Right next to the home, Furman University students would cut over to Main Street for many years on a path that led up the hill from the school.

In the first decade of the twentieth century, Camperdown reopened and the Touchstone house had people moving in and out. A.R. Black lived in it from 1899 to 1900, I.C. Newton from 1901 and 1902 and G.W. Charlotte lived in the house in 1903. By the second decade of the century the house became Curry's Gasoline Station when auto-related businesses were taking over the majority of commercial buildings in the West End. Later it was People's Service Station.

In the mid-1970s plans were put in motion to begin revitalizing Falls Park as well as the Touchstone cottage. The Carolina Foothills Garden Club took over the house in a state that would be unrecognizable today. Later the home was renovated to what is believed to be near its original look and housed the Metropolitan Arts Council. When the beautification of Falls Park was underway, the Touchstone house was an integral part of the plan as a "gateway" to the historic park site. The home is now known as Falls Cottage and for years has operated as a successful and charming restaurant with perhaps the best view of Falls Park.

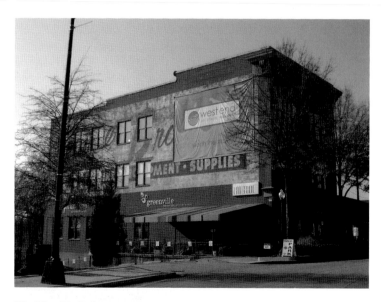

The West End's first structure over three stories was the 1911 Geer-Thompson Building, which started out as a wholesale drug warehouse before becoming a Ford Model T dealership.

15. Geer-Thompson Building

Until the late nineteenth century, the eastern side on the curve of South Main Street overlooking the Reedy gorge remained undeveloped McBee family land. The first permanent structure was the Touchstone house, which still remains. The second building on the curve came in 1911 when Geer Drug Company purchased the property and built a four-story brick building for nearly $20,000 to serve as a wholesale drug distribution center. The architect for the building was Joseph T. Lawrence, who also designed the city's 1915 jail on Broad Street and the Davenport Apartments on Washington Street. However, Geer Drug stayed in the building for less than two years before Thompson's T-Model Ford Agency moved into all four floors. Henry Ford started Ford Motor Company just ten years before the dealership opened in Greenville, which was the first Upstate Ford dealership. The same year Thompson's opened, Ford revolutionized the auto industry by using standardized interchangeable parts and assembly line techniques to boost efficiency and production. After five years in business, Thompson's agency helped the Model T to have a 50 percent market of all cars sold in America.

On street level, pedestrians could admire the showroom models through the large glass doors. A large car elevator on the left side of the building was installed to shuttle the cars from one floor to the next. The second floor above street level was used as the garage to work on cars, while the top floor stored an inventory of new autos such as the popular Tin Lizzies, Touring cars and Model T Runabouts. Thompson's was the largest, but only one of the many car dealerships that was located in the West End in the 1920s. Locals at that time would come to the West End for all their automotive needs. Today locals flock to the West End for the restaurants, recreation and baseball games.

Thompson's Ford occupied the building until 1924, and a few years later Piedmont Battery opened its doors there for a brief period before Davis Used Cars did business until 1940. Dan Tassey's auto trimming business moved in for the next decade until Harper Brothers Office Supply bought the building. In the "modern art" decade of the 1950s, Harper Bros. followed the contemporary vogue to "modernize" old brick facades with galvanized aluminum sheathing. Forty years later the Harper family applied for the building's inclusion on the National Register of Historic Places (and received this honor in 1998) after it removed the ugly alterations and restored the building to its historic look. Harper's was the longest running tenant in the building's history, so it is sometimes referred to by locals as

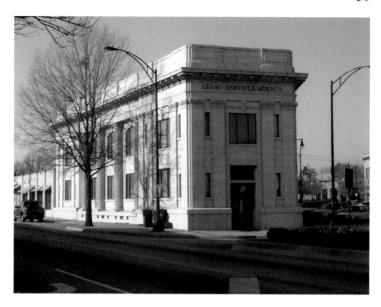

The American Bank Building at the apex of the intersection of Augusta
Street and South Main Street began as a drugstore in the 1870s and was
remodeled to its current style in 1920.

the Harper Bros. Building. An advertisement for their business
partially obscured by window cutouts and a banner remains
along the entire north side of the building today. Harper Bros.
moved out in 1988 due to the proliferation of specialty office
supply chains like Office Max and Office Depot.

16. American Bank Building

The intersection of Augusta Street and Pendleton Street (recently
made an extension of South Main Street) causes a triangular
shape of property at the fork of roads leading to Augusta and
Pendleton. As a result, the building at the junction takes on a
shape distinct from the surrounding buildings. In the 1870s, the
young Dr. Thomas T. Earle built a triangular drugstore there fresh
after returning to Greenville after graduating from Columbian
Medical College in Washington, D.C. It was among the early
commercial ventures in the West End. Born in Greenville in
1845, Dr. Earle went on to become one of the oldest established
and respected physicians in the city. The building survived the
rare tornado in 1884 that destroyed several buildings in the
immediate area, but the drugstore had vacated by 1888. Earle
went on to become the president of the Greenville County
Medical Society, president of the South Carolina Medical

Society and surgeon for the Southern Railroad Co., the C. & W.C. Railroad and the Greenville Traction Co.

In 1890, the American Bank was organized under the leadership of bank President Henry Briggs, Walter Gassaway and R.E. Allen and took over Earle's drugstore site. The bank was a two-story Victorian brick structure with a decorative porch facing the muddy streets at its apex. On top of the building was a large "American Bank" sign surmounted by a ten-foot decorative eagle. It was the first bank to locate in the West End, indicating the residential growth and financial prospects of the area. Cotton was arriving regularly in the nearby railroad depot to serve the Camperdown Mills and the Huguenot Mill. Offices on the second floor included West End Dental, run by Dr. Paul A. Pressley.

The bank's presence was strengthened when it had its outdated building remodeled in 1920 in the regal Beaux-Arts style. Bank officers hired Olin Jones, the same architect who had supervised the building of the new Greenville County Courthouse four years earlier. Fortunately the American Bank building survived the years of West End's economic decline in the last half of the twentieth century to see its resurrection in the early twenty-first century. In 1980 the Legal Services Agency renovated the building and its signage remains across the front today. This building endures as a testament to the West End's first commercial development in the late 1800s and its vital role in the city's overall charm today.

17. Farmers' Alliance Cotton Warehouse

One of the earliest surviving cotton warehouses in Greenville today is a brick two-story cotton warehouse dating to 1890 within the present structure (the façade is later). Jacob Cagle, one of the most important local builders in the late nineteenth century, was in the midst of adding a cupola to Robert Mills's old courthouse (by then the Records Building) at Court Square when he received the commission from the Farmers' Alliance to build this new cotton warehouse. Greenville's textile industry was taking off and the demand for cotton in the local mills was heavy. Fortunately, cotton didn't have to travel far to supply the city's demand. When the Farmers' Alliance warehouse was built, Greenville County was producing nearly thirty thousand bales per year. Nine mills were in operation, including Pelham Mill, Batesville Manufacturing, Reedy River Manufacturing, Huguenot Mill and the mighty Piedmont Manufacturing Company.

The Farmers' Alliance movement began in Texas during the height of economic depression (1876) to protect the interests of

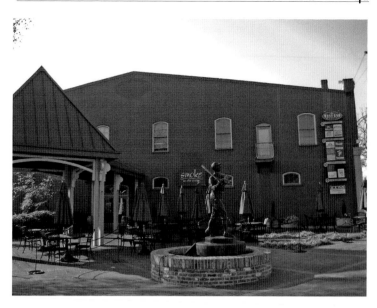

The West End Market began as a cotton warehouse in 1890.

small farmers. Trying to get back on their feet after the Civil War was particularly hard for farmers. Postwar Confederate money had become worthless and commodity prices fell, putting farmers into deep debt. Banding together became an economic necessity in order to eliminate middlemen in the cotton selling business. The Alliance organized in the Greenville area in the late 1880s and soon began holding meetings in the Gothic courthouse downtown. The Farmers' Alliance warehouse was erected as a result of forty-two regional alliances who sought to bypass the large commodity brokers—thereby boosting their profits. Besides a warehouse, the building also housed an Alliance bank and headquarters of the State Alliance Exchange—another evidence of Greenville's growing lead in textile business. The right half of the building was added in 1891.

In the later twentieth century the building was bought by Harper Bros. Office Supply (in the nearby Geer-Thompson Building) to use as a warehouse. Fortunately the building was spared demolition and was instead part of the early phase of the West End's revitalization. Much of the original woodwork is preserved inside and unique retail shops and restaurants buzz with activity. Now known as the West End Market, the building is one of the few remaining direct icons of downtown Greenville's textile past.

18. Shoeless Joe Jackson Statue

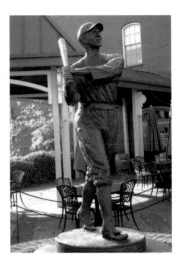

The baseball player represented in this statue is perhaps Greenville's most famous native. Joseph Jefferson Wofford Jackson was born on July 16, 1888. His parents, George and Martha, soon followed the path of many farmers of the late nineteenth century to work for more reliable money in a textile mill. They obtained jobs at the new Brandon Mill in west Greenville and moved into the mill village. When Joe was a boy, he began working in the mill along with his parents. Though he only swept floors at first, America didn't have child labor laws yet and it was common for young children to work twelve-hour days. At the age of thirteen, Joe began playing for the Brandon

This life-size bronze statue of Shoeless Joe Jackson was sculpted by Greenville artist Doug Young. The bricks encircling the base are salvaged bricks from the old Comiskey Park in Chicago, where Joe used to play for the White Sox.

Mill baseball team in the regional Textile League. Each mill community had baseball teams that would play each other. Joe was so good as a boy that he began playing with the adults on the team. Joe was known for his strong arm but even more for his hitting—good enough to get him signed for the minor league Greenville Spinners in 1908. He made seventy-five dollars a month with that team, which was significantly more than he was making as a millworker. The same year he also married his sweetheart, Kate Wynn, and they both initially lived with Joe's parents at 104 Sturtevant.

While playing for the Spinners, Joe Jackson acquired a nickname that would stay with him the rest of his life. In a game against the Anderson Electricians, Joe was playing with new cleats that did not fit just right and were not broken in yet. His feet began hurting, so late in the game he could not stand the pain any longer and he decided to take his cleats off before he got up to bat. Nobody noticed while he was at the plate, but he got a good hit and started rounding the bases. Someone from the stands is reported to have noticed him running in just his socks and stood up and yelled, "You shoeless son-of-a-gun!" Local sportswriter J. Carter "Scoop" Latimer is said to have been the one who heard the comment and started referring to him as Shoeless Joe Jackson.

Philadelphia As owner Connie Mack signed Joe later in 1908 for a Major League contract, but he only played a partial season in Philadelphia and also in Cleveland for the next two years. After only 115 times at the plate since 1908, in his first full season with the Cleveland Naps in 1911 he jumped to 571 at-bats. He was a rookie sensation and ended the season with a .408 batting average. He continued to bat extremely well, but was always statistically overshadowed by the great Ty Cobb. When Jackson was hired by the Chicago White Sox in 1915, his salary jumped to $6,000 a year. After two years with the Sox, they went to the World Series and beat the New York Giants. In 1919 the White Sox returned to the World Series and lost. In spite of an astounding fielding effort and a .375 series average, Joe Jackson and seven of his teammates were accused of intentionally losing the series—infamously known as the Black Sox scandal. A grand jury investigated during the next year and later acquitted the men in 1921. Nonetheless, the new commissioner of baseball, Kennesaw Mountain Landis, banned Joe and the others from playing Major League baseball and also from the Hall of Fame. Joe maintained his innocence for the rest of his life and fans continue to await his reinstatement to MLB and his election to the Hall of Fame.

Amazingly, Jackson never won a batting title during his career in spite of hitting over .370 four different seasons. Ty Cobb is the only hitter who could have overshadowed Joe consistently during those years. Nonetheless, Joe continues to hold some of baseball's most significant statistics. His lifetime batting average of .356 is the third highest in league history, while his .401 rookie season batting average remains the best any player has ever hit in his first season.

After being forced out of the game he loved, Joe and his wife moved to Georgia and opened up a dry cleaning business to make a living. He kept up with baseball, nonetheless, by playing and coaching with various semipro teams for the next eleven years before moving back to Greenville in 1932. He came full circle to the beginning of his career by signing on with the Greenville Spinners for the rest of their 1932 season. The ensuing years were spent playing and coaching various teams in South Carolina, including some of the mill teams he had played in the Textile League as a teenager. Instead of getting into the dry cleaning business again, Joe opened up a barbeque restaurant at 1605 Augusta Road. He later opened a liquor store at 15 Pendleton Street, which he ran until the end of his life.

After living near their liquor shop in an apartment (#4) at 204 Pendleton Street, Joe and Kate Jackson built a modest brick home at 119 East Wilburn Avenue in 1941. Since the

Jacksons never had children, they did not need a lot of space for just the two of them. The two-bedroom and two-bath home was only 1,055 square feet, but it suited their needs and was not far from where Joe grew up and played at Brandon Mill. Over the ensuing years, Joe continued to hit balls with the local boys, though the Jacksons preferred to keep a low profile—despite his illustrious past as one of baseball's greatest hitters.

Joe Jackson and his family worked at Brandon Mill in the early 1900s when Greenville was fast becoming a leading producer of textiles.

Next to Brandon Mill is the Shoeless Joe Jackson Memorial Park—site of the original field where Joe played for the Brandon Mill team. The restored baseball field opened on March 30, 1996.

The Shoeless Joe Jackson Museum and Research Library is the home Joe and his wife built and lived in for the latter part of their lives.

Joe Jackson died of a heart attack on December 5, 1951. The burial was held at the newly opened Woodlawn Cemetery on the edge of town off Wade Hampton Boulevard. Even today, more than fifty years after his death, kids and adults alike frequently leave baseballs, bats and other personal items at Joe's gravesite in honor of his lifetime achievements and inspiration.

The sculptor for this statue is a local artist, Doug Young. Greenvillians had the unique opportunity to watch this sculpture being created in clay as the sculptor worked on it for many months in the city hall lobby. After being cast in bronze, the statue was dedicated on July 13, 2002, with guest speakers including Tommy Lasorda (who played on the 1949 Greenville Spinners team).

Next to the Fluor Field at the West End is the home that Joe and Kate Jackson built and lived in until their deaths. The home was moved about two miles from its original location in 2006 to reside next to Greenville's new baseball stadium. The home is now the Shoeless Joe Jackson Museum and Research Library, which opened on June 21, 2008. In a poetic tribute to Joe's career accomplishments, the museum is located at 356 Field Street, the same number as his lifetime batting average.

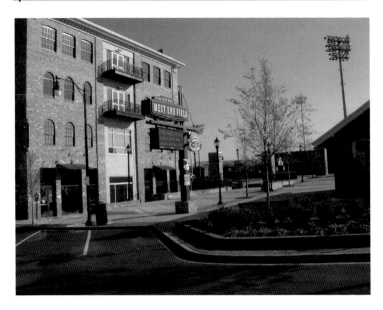

The Fluor Field is one of the key factors in the West End's revitalization in the twentieth century.

19. Fluor Field at the West End

The site of the present-day baseball stadium is the location of two of Greenville's most significant developments. The first goes back to the days when this area of town was still mostly wide-open land with homes scattered along the dirt roads going to Augusta, Georgia, and Pendleton, South Carolina. For a large part of Greenville's history the northern edge of this site (beyond the ballpark's outfield) was a freight train terminal for the first railroad that came to the city. The College Station passenger depot was a little farther east along Augusta Street (right around the corner from where the Shoeless Joe Jackson Museum now stands). The driving force behind the effort to bring the Greenville and Columbia line was Vardry McBee, one of the most important visionary businessmen Greenville has ever known. After significant financial setbacks and a concerted effort by the city of Anderson to reroute the line to their city, Vardry backed the project with an unprecedented investment of $50,000 to bring the line to Greenville—the largest private investment in the railroad in U.S. history to that point. The move was enormously risky, but Vardry had lived in Greenville long enough to know that there was great potential here. Railroads fueled commerce, trade, development and the opportunity for convenient passenger travel, bringing a whole new dimension to the city's economic profile as well as contact with the rest of the

country. Greenville's first train arrived through this site to great fanfare on December 8, 1853; 153 years later, Greenville's new minor league baseball stadium opened to great fanfare on its opening day in 2006.

With Greenville being home to one of the greatest baseball players in history—Shoeless Joe Jackson—it is only fitting that the city should have a thriving baseball scene. In more recent years, the Greenville Braves (AA minor league farm team for the Atlanta Braves) maintained a dedicated fan base from 1984 to 2004. Such illustrious all-stars as Chipper Jones, Tom Glavine, Javier Lopez, Andrew Jones and John Smoltz have thrilled many while playing in Greenville. The Braves' stadium (Greenville Municipal Stadium) was well outside of town on Mauldin Road, making it difficult to quickly reach. As Greenville's downtown became more and more of a success story, talk of relocating the stadium downtown became serious. Plans were stalled and the Braves grew anxious about no firm commitment of a new stadium, so they left Greenville for Pearl, Mississippi. Columbia's Capital City Bombers (a Class A minor league team) decided to relocate to Greenville. By that time plans were being made in earnest for a downtown ball field (eagerly supported by city officials), though the team still played in the Municipal Stadium for a year. The Bombers were renamed the Drive, reflecting the city's new economy largely driven by mega automotive corporations like BMW and Michelin. The Drive's parent team, the Boston Red Sox, has enjoyed great recent success, including momentous World Series victories in 2004 and 2007.

The West End Field opened its doors for the first time on April 6, 2006, after less than one year of construction. The stadium held 5,700 seats (since expanded) and is a scaled replica of Boston's Fenway Park. The outfield fence's dimensions match those in Boston and also repeat Pesky's Pole down the right field line. There is even a thirty-foot version of the Green Monster. The intimate design of the grandstands leaves even the "cheap seats" in the back row no more than thirteen rows from the field! In early 2008, Fluor Corporation, one of the city's largest employers, bought the naming rights and the ballpark was renamed Fluor Field at the West End.

When you enter from the corner of South Main Street and Vardry Street, the charming building housing the team store is a restored fire department house from the 1930s. The bricks are worn with character from decades of weathering and blend remarkably well with the look of the bricks of the stadium. Why? The stadium itself is tied to Greenville's (and Shoeless Joe's) textile past through its construction, with half a million bricks salvaged from an old textile mill in Joanna, South Carolina. So even though the ballpark is new, the bricks used to build it are

even older than the ones that make up the historic team store building.

The opening season brought over 330,000 fans "out to the ball game" with an average of 4,800 fans per game. After $1 million in improvements between seasons, the team's second year (2007) broke the attendance mark for the first year with a final visitor total over 339,000. Beyond approval from the fans, the park also won cyber recognition with a Ball Park of the Year award from www.Ballpark.com after its rookie season. While the reasons for these accolades are quantifiable, the quality of life dimension the Fluor Field brings to the city is less tangible, yet is the greatest reward of all.

Tour 2

South Main Street
Reedy River to Coffee Street

J ust north of the Reedy River on Main Street is where Greenville's earliest settlement began. Richard Pearis, Greenville's first colonial settler, built his late eighteenth-century home in this area north of the river, likely on present-day East Court Street between Main and Falls Streets. Families slowly started to move into the region, but the ongoing struggle for independence from Britain stifled South Carolina's government from incorporating the newly acquired land. The real population increase came in 1784, when the state created a land office to sell former Indian lands and bring down the postwar debt. South Carolina emerged from the Revolutionary War with twice as much debt (over $5.3 million) as any other state.

On the first day the land office opened, Colonel Thomas Brandon of Union bought all of Richard Pearis's former land, including the present-day site of Greenville. Other tracts frequently went to Revolutionary War soldiers with credits issued by the government in payment for their service. The population over the next six years jumped from about 50 people to just over 6,500 in the area now occupied by Greenville County. Shortly before the turn of the century in 1797, one of the village's early leaders, Lemuel Alston, laid out the first plan for the village and called it Pleasantburg. No records exist to tell us what the nature and orientation of the city were like before this plat. Alston created a grid of fifty-two lots generally in a north-to-south axis. There were only two named streets in this early plan, both of which were covered in grass. Present-day Main Street was simply known as "the Street." What is now McBee Avenue was then known as "the Avenue."

By 1825, the village had grown to seventy-five residents and about five hundred buildings. Highlights of Greenville's history from around 1825 through the next hundred years will

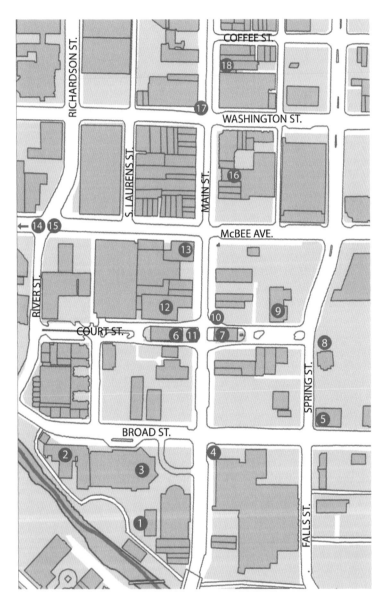

Tour 2: South Main Street—Reedy River to Coffee Street. *Courtesy of the City of Greenville.*

Lemuel Alston's 1797 plat (which he called Pleasantburg) was the first organized plan for the village of Greenville.

be revealed through the enduring buildings, monuments and history explained in the following tour.

1. Gower, Cox and Markley Carriage Factory

For nearly a century, what is now known as the Peace Center complex area was the site of one of the busiest and most successful businesses in Greenville's early history. In 1835, the Gower & Cox Wagon and Carriage Factory was started by blacksmiths Ebenezer Gower and Thomas M. Cox. When Ebenezer's younger brother, Thomas Claghorn Gower, joined the company they changed their name to the Gower, Cox and Gower Carriage Factory. Along the north bank of the Reedy River beside the footbridge stood the main building, with a large water wheel to power the factory. Locals would entertain themselves by standing on the bridge and watching the wheel turn with the river's current.

In 1853, H.C. Markley became a fourth partner in the business—then named Gower, Cox and Markley Carriage Factory—and they continued to prosper, erecting the present three-and-a-half-story brick building in 1857 with a distinctive slanted roofline. Not one nail was used in its construction— only handmade bricks and mortar and massive beams pegged together. The building, set off the river by about fifty feet, originally was used for carriage storage and display, with the lower floor serving as a blacksmith shop. By the last decades of the nineteenth century, there was a lumber shed on the bank of the river exactly where the open-air amphitheater is today and a wheelhouse on the banks right next to the Main Street Bridge. A paint shop, carriage and wagon warehouses, a hardware

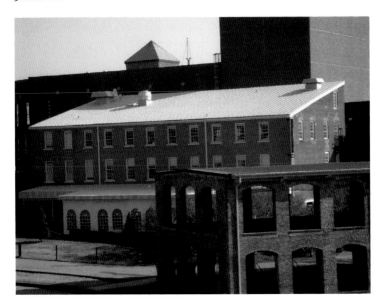

The 1857 Gower, Cox and Markley Carriage Factory building is the oldest industrial building in downtown Greenville. Before textiles became the city's claim to fame, the carriage-making industry is what we were most known for.

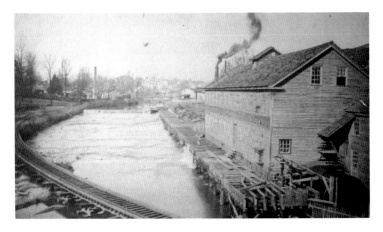

The old wooden Gower & Cox Wagon and Carriage Factory's wheelhouse stood for many years in the area now between the Wyche Pavilion and the Main Street Bridge.

store and office building were among the other buildings in the carriage factory's complex. The Markley Hardware store and office building built in the early 1900s still exists today (it's the brick building that fronts South Main Street and projects back near the 1857 building). Production in the Greenville facility outpaced all others south of Washington, D.C., putting

Greenville on the map as an industrial transportation center long before textiles became the city's enduring claim to fame. Textile production would rule Greenville's economy for nearly a century beginning in the late 1800s, coming full circle back to a transportation center with such modern-day factories as BMW's plant, as well as other important facilities at Michelin and CU-ICAR.

At the start of the Civil War, businesses like the Gower, Cox and Markley Carriage Factory were immediately put into service for the Southern cause. Many of the workmen left to fight, though Thomas Gower returned after a year to resume running the factory. After four years of supplying a steady stream of hundreds of wagons and caissons for Confederate soldiers, the government owed them an enormous amount of money that it could not pay back in full.

In 1904, a two-story brick paint shop was built by J.E. Sirrine for the Greenville Coach Factory (as it was now called), but the coming of the automobile was the death knell for the production of wagons and carriages. Markley decided to sell the business in 1911, bringing a seventy-six-year industrial chapter in Greenville's local history to a close. The closing of one chapter would soon lead to the start of another, however. In 1925 the old carriage factory paint shop building became the first factory for the production of Duke's mayonnaise—another Greenville success story with a hugely significant presence in

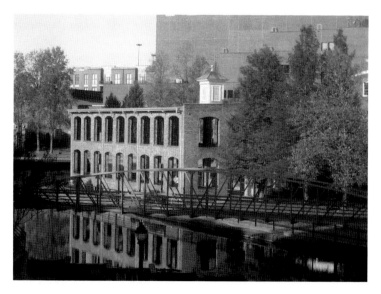

Today's charming Wyche Pavilion began as a paint shop for H.C. Markley's Greenville Carriage Factory and was later used as the first factory for Duke's mayonnaise.

the South even today. Mrs. Eugenia Duke was an ordinary Greenville mother who loved to cook. What was unusual was the unique taste of her homemade mayonnaise. Her recipe was thought up and perfected in her house on Manly Street near downtown Greenville. During the Great War in 1917, Mrs. Duke sold homemade sandwiches with their unique taste coming from the mayonnaise spread (mayo had only been commercially available in the United States for five years prior to Mrs. Duke's foray into the sandwich-making business). Word spread quickly about them and demand grew—especially from soldiers stationed at Greenville's World War I Camp Sevier. Over thirty thousand soldiers were stationed there and many of them loved to feel a sense of "home" with a taste of Mrs. Duke's delicious sandwiches. Locals also wanted the mayo at home and Mrs. Duke decided to expand her business, buying the old Greenville Coach Factory paint shop on the banks of the Reedy River. Local drugstores such as Carpenter Bros. sold her sandwiches, while grocery stores started marketing her mayonnaise. Both were a hit, but Mrs. Duke decided to sell her sandwich-making business to concentrate on taking her spread to a larger regional market. Duke's Sandwich Shop still operates today at several locations, while Duke's mayonnaise was eventually sold to C.F. Sauer Co. in 1929, but still operates under the name that made the product famous. The 1857 and 1904 carriage factory buildings were placed on the National Register of Historic Places in 1979.

A larger Duke's plant was built in 1955 just off Laurens Road in Mauldin to take on the increasing production demands, which became so great that the plant has expanded at least seven times. The modern facility is well over 300,000 square feet—a far cry from its modest beginnings in this charming building on the edge of the river. Today Duke's is still a secretly guarded recipe and is the only large mayonnaise company to use only yolks (no egg whites) and is sugar free. The Mauldin facility remains the sole producer of the South's favorite sandwich spread and the original factory on the banks of the Reedy is now named the Wyche Pavilion. It serves as an open-air venue for such events as wedding parties, political rallies and business meetings, to name a few.

2. Huguenot Mill

This beautiful old two-story brick building is the only complete textile mill still existing on the Reedy River in downtown Greenville. It is also one of the earliest mills built in the city (1882), completed less than a decade after the first postwar

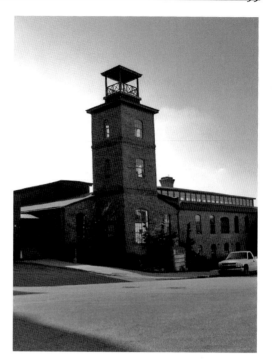

The 1882 Huguenot Mill was downtown Greenville's third textile mill built on the Reedy River. It is the earliest mill still standing in the city.

mill built in the county. The textile industry's takeover was just in its infancy with the erection of this mill. At the time, the county's largest manufacturing sector by far still came from the archaic grist- and corn mills, numbering nearly one hundred countywide. In terms of capital investment, however, textile mills dominated, with nearly $1 million and a product value over $2 million (as opposed to total grist- and corn mill product value near $150,000.) Charles Lanneau and Charles Graham organized the mill at a cost of $150,000.

Period maps reveal that the part of the current building that runs north and south was the first portion built. In 1888, the distinctive tower at the northeast corner of the building and the east-to-west portion of the building fronting Broad Street were added. The tower was originally used for ventilation, water storage and a staircase. Freestanding buildings around the factory included a picker house to the south, drying room and dye house to the west and an office off to the northwest. The mill employed 40 workers after its first two years, grew to 150 over the next four years and doubled to 300 by 1898.

Since the mill is built on the banks of the river, you'd expect that it was water powered, like its predecessors. However, the Huguenot Mill was the first steam-powered mill in Greenville, powered by a large Corliss engine. These engines were especially sought after by textile mills for their ability to provide

large amounts of energy while still capable of precise speed adjustments to keep from breaking the threads. Many of the early postwar mills in the county produced cotton threads and other unfinished textile products. The Huguenot Mill made more elaborate fabrics like plaid, gingham and cottonades in their factory—something no other mill in South Carolina was doing in the early 1880s.

After falling on hard times in the early twentieth century, the Huguenot Mill folded and a new textile operation took over in 1910. Nuckasee Manufacturing Company produced men's undergarments and union suits in the facility—the first in South Carolina to make a full, finished garment with cloth manufactured and bleached by other mills in the same city (and cotton grown in the county too). Union suits took their name from the uniting of the torso and leg elements into one garment. The first union suit was patented in 1868 and was made with flannel cloth. By the time Nuckasee began operation in Greenville, the state of South Carolina was a leading center of production for American's popular underwear industry. Gilreath Manufacturing Company, another large underwear producer, also began in 1910 and operated across the river on the northeast corner of River Street and Hammond Street (now Camperdown Way). The *Greenville News* advertised that "Nuckasee under wear is sold and known all over the country." The mill was eventually sold to Union-Buffalo Mills in 1929, converted for use by the Carolina Blouse Co. in the 1950s and later became Ruth Fashions Company into the 1970s. When the Peace Center was being built in the late 1980s, Allan J. Graham Jr., grandson of one of the mill's founders, donated $1 million to renovate the building (already on the National Registry of Historic Places) and save it from being torn down. The restored building now houses various offices.

The mill's adjacent two-story brick office building is another important historical structure built at the beginning of the twentieth century. After remaining vacant for many years, it became the headquarters for the Greenville County Historical Preservation Commission in 1979. The building remains a charming reminder of Greenville's textile past.

3. Peace Center for the Performing Arts Complex

Greenville struggled in the 1970s and '80s to attract people to its downtown. The department stores that had previously kept Main Street buzzing with activity had all moved out to the malls in the surrounding regions. City leaders sought for marquee tenants that would attract people back for downtown leisure

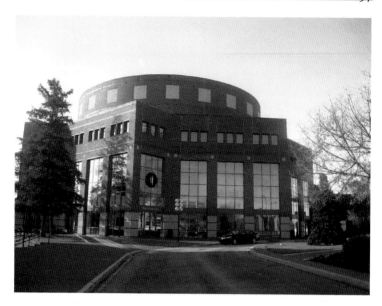

The Peace Center for the Performing Arts is one of the region's premier entertainment venues and played a crucial role in the revitalization of downtown Greenville.

and entertainment. They found the perfect answer in the Peace Center for the Performing Arts, a high-class venue that presents the world's finest performing artists at Greenville's doorstep.

When the location was decided to be the old Greenville Coach Factory property on the north bank of the Reedy, a number of buildings had to be torn down. Decisions had to be made about several old buildings—whether to keep and restore them or tear everything down and start over. Fortunately, the 1857 carriage factory building was spared from demolition with a $1 million donation from the Roe family. The adjacent 1904 paint shop for the carriage factory was also saved. On the west end of the property, the 1882 Huguenot Mill and office building were restored and provide an irreplaceable charm to the complex.

The Peace Center opened to public acclaim in November 1990. The final cost was $42 million, raised through a combination of public, private (over 70 percent) and corporate funds. The center was named for the Peace family, who contributed $10 million to the capital campaign in honor of Roger C. Peace, B.H. Peace Jr. and Frances Peace Graham. From the start a major component of the Peace Center's mission was to sustain state-of-the-art venues, which it has done to a degree only found in much larger cities in the South like Atlanta and Houston. The main concert hall seats 2,100 and the adjacent Gunter Theater seats a more intimate 400 guests.

The quality and variety of entertainment that the Peace Center brings to Greenville contribute significantly to the overall cultural smorgasbord found in the city. Top-notch Broadway shows and musicals are presented with the likes of *Les Miserables, Phantom of the Opera, Chicago, My Fair Lady, 42nd Street, Mamma Mia!, The Producers* and *Rent*. Musicians ranging from Yo-Yo Ma, Natalie Cole, Aretha Franklin, Wynton Marsalis and Michael Bolton have thrilled locals and regularly bring in guests from hours away. The internationally acclaimed entertainers brought to Greenville through the Peace Center are of the caliber that you would enjoy in Manhattan, Chicago and Los Angeles.

In the late twentieth century the Peace Center played a key role in the revitalization of downtown Greenville. Its important contribution to the overall quality of life in the twenty-first century is a great "perk" for locals and a real draw for families looking to relocate to our city.

Revolutionary War hero and Greenville namesake General Nathanael Greene is honored with a bronze statue on the corner of Main and Broad Streets.

4. Nathanael Greene Statue

The man depicted in this slightly larger than life-size bronze statue was one of the great war generals of America's fight for independence—Nathanael Greene. Thomas Jefferson described him as "second to no one in enterprise, in resource, in sound judgment, promptitude of decision, and every other military talent." Nathanael was born in Potowomut, Rhode Island, and was raised by a conservative Quaker family. His patriotic duty was aroused at a military parade and he eagerly joined a county militia in the fall of 1774. The next year Rhode Island organized an army in response to the "the shot heard 'round the world" at the battle of Concord and appointed Greene as brigadier general. A few months later, he was promoted to brigadier general of the Continental army—the youngest appointed to the position to that date.

In 1780, George Washington needed a strong leader to turn the Continental army's fortunes in the South and appointed Greene as Southern commander. Under General Greene, troops were able to regain the lower Southern states from British control and force them to retreat for ultimate defeat at Yorktown. Greene was instrumental in cleansing South Carolina of British occupation. In 1786, General Greene died and South Carolina honored him the same year by naming its new county in the northwest part of the state Greenville County. While no original evidence exists for the origin of Greenville's name, it was common practice at the time to name counties and cities in honor of Revolutionary War heroes like Nathanael Greene. A number of prominent politicians in later years, including John C. Calhoun and Benjamin Perry, confirmed the connection of our city with the general.

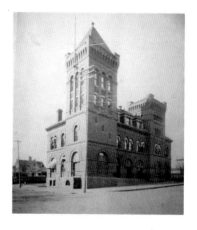

On the northwest corner of Broad and Main Streets, the city built a new post office in 1892. In 1938 it became Greenville's City Hall until it was demolished in 1972. A new Marriott hotel was built on the site in 2010. *Courtesy of the Greenville County Library System.*

The seven-foot-tall bronze figure was created by sculptors T.J. Dixon and James Nelson and dedicated on July 27, 2006—the 264th anniversary of Greene's birthday.

5. Working Benevolent Temple and Professional Building

As the textile industry fueled Greenville's downtown building boom in the 1920s, most of the construction centered on Court Square and extended north along Main Street (such as the Woodside Building and the Keith Building). These inevitably served the prospering Caucasian businessmen running the mills and banks. However, Greenville's African American community was also making strides in the professional world, despite the ongoing presence of segregation. Perhaps the most significant signal of the advancements was the construction of the Working Benevolent Temple and Professional Building in 1922 on the northeast corner of East Broad and Falls Streets. Financing was provided by the Working Benevolent State Grand Lodge of South Carolina, a society dedicated to the health, welfare

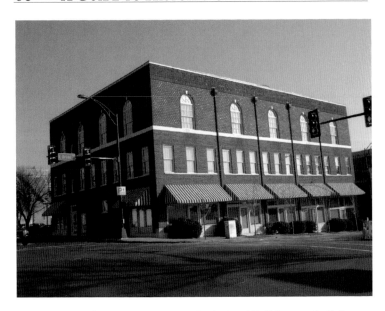

The Working Benevolent Temple and Professional Building was built in 1922 and served the needs of Greenville's African American community through some of its most difficult times of struggle.

and burial benefits of African Americans. Two years before the temple opened, the lodge began its outreach into Greenville with the establishment of the Working Benevolent Society Hospital on the corner of Green Avenue and Jenkins Street. The temple became the headquarters of the lodge and held its administrative offices.

The handsome three-story brick building spans 21,000 square feet, extending 100 feet along East Broad and 75 feet along Falls Street. Storefronts originally lined the south and west street sides of the building, giving entrepreneurs a chance to start up small businesses. One of these was Clarence Peters, who was one of the first tenants of the building when he opened up a barbershop in 1923. Peters is one of the many who benefited from the opportunities the temple provided for the African American community. Other owner-operated businesses located there included cafés and a drugstore. The second floor of the temple also housed crucial downtown office space for a number of the community's African American lawyers, dentists, insurance agents and doctors, as well as organizations like the South Carolina Negro Life Association. Not only were the needs of the living served in the building, but Greenville's first African American mortuary was also located here for many years. During the civil rights movement in the 1950s and '60s, the temple was the focal point of organization and discussion

as African Americans sought to gain equal political and social freedoms. After many decades of use, the building was largely abandoned in the early 1980s except for Clarence Peters's barbershop. The temple escaped demolition and was instead accepted into the National Register of Historic Places in 1982. Nearly $1 million in renovations brought the deteriorating building back to life in 1983. Dunlop Sports Corp. expanded its Greenville headquarters to the building in 1985 and in recent years it has served as the offices for Erwin-Penland Advertising.

By the time the temple was built, the African American community already had a dominant presence in the area. The most significant development for meeting their social needs was the organization of the Phillis Wheatley Center by the twenty-three-year-old Hattie Logan Duckett in 1919. Hattie visited a friend in Cleveland, Ohio, who started an African American social service facility called the Phillis Wheatley Center (honoring America's first black woman poet). After her visit, Hattie was inspired to minister to the needs of Greenville's African American community in the same way. A home was purchased on East McBee Avenue to house and teach girls to be good and productive members of society. Hattie's efforts not only inspired local African Americans, but also Caucasian business leaders. Thomas Parker, a local textile mogul whose company owned 11 percent of all state mills, became president of a newly created biracial board of trustees and helped raise money for building a new facility.

In 1924 a three-story brick building was built at 121 East Broad Street, next door to the Working Benevolent Temple, with money generously contributed from both black and white donors. Community outreach was greatly enhanced, with facilities that included an auditorium, classrooms, nursery and the first public library for African Americans in the state. Within a year over forty thousand visitors were registered and children participated in activities and classes that included Bible, sewing, music and voice training. Several hundred adults helped host activities and club meetings at the center year-round.

During the Depression years, the Phillis Wheatley Center provided much-needed clothing provisions, food relief, coal for heating and shelter for those who lost their homes. The presence of the neighboring Balentine Meat Factory didn't help matters. The cattle stalls, brine tanks, slaughter rooms and a noisy railroad line were all located directly behind the center. Perhaps patrons obtained some relief through the indoor basketball court or the large pool in the adjacent lot. A USO headquarters was created there for black GIs stationed at Donaldson Air Force Base during World War II.

The center moved in 1977 to its new $1.6 million facility on Greenacre Road and continues to minister to the health, social,

artistic, spiritual and educational needs of Greenville's African American community. Hattie Logan Duckett died in 1956 and was buried in Richland Cemetery. However, her spirit lives on through the staff and activities of the vital community center she established in 1919.

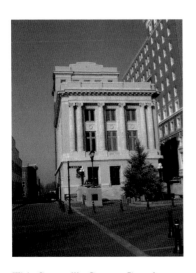

This Greenville County Courthouse was built in 1916–18 by noted architect Phillip Thornton Marye, whose firm went on to design Atlanta's famous Fox Theatre.

6. Greenville County Courthouse

Greenville's population grew rapidly toward the middle of the nineteenth century and businesses (especially Vardry McBee's) were plentiful. A new courthouse, larger than the one Robert Mills designed in the 1820s at the village square, was needed to meet the needs of the district.

In 1855, Greenville's next courthouse was built across the street from Mills's courthouse on a site in front of the town's market house. The imposing Neo-Gothic building was designed by Charleston architect Edward C. Jones, who had recently finished Furman University's campus as well as the church of St. John in the Wilderness (still existing) in Flat Rock, North Carolina. The three-story building had lancet arch windows with a soaring four-story central tower on the façade. It looked more like a church than a courthouse, but was a popular style in this era. Its courtroom held five hundred people, which was adequate for several decades but was outgrown, outdated and leaky in the early twentieth century. It was torn down in 1915 to make way for the county's next courthouse on the same lot.

Construction for the new courthouse began in 1916 after attempts were made (and rejected) to reuse the walls of the 1855 courthouse and mimic the façade of the courthouse across the street. America's involvement in World War I stalled progress until the courthouse finally opened in January 1918 at a cost well over $150,000. The notable architect was Philip Thornton Marye of Atlanta, whose firm a decade later built the exotic Yaarab Temple (later Fox Theatre) in his hometown. The local

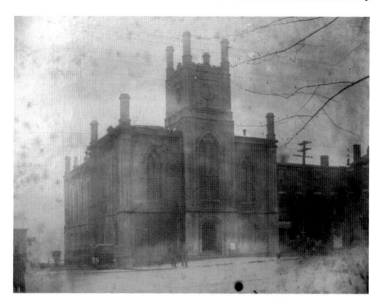

Greenville's 1855 County Courthouse was built in the Neo-Gothic style by Charleston architect Edward C. Jones. The Mansion House can be seen to the right. *Courtesy of the Greenville County Library System.*

supervising architect was Henry Olin Jones, overseeing the construction by James A. Jones from Charlotte.

Its design is in the Beaux-Arts style, which originated in the School of Fine Arts (École des Beaux-Arts) in Paris. American architects were admitted to the school in the mid-nineteenth century and brought back its influential style to students in the United States. The classical style dominated American architectural philosophy for almost a century before modern design took over.

The cream-colored brick building is set back off Main Street much farther than its predecessor. Three stories housed the courtroom and judges' chambers in the front portion while the rear elevation soared five stories higher to house the county's and sheriff's offices. The façade's six half-round fluted Ionic columns set the tone for the Beaux-Arts style of the building. It is here that we find a unique architectural modification to reflect the local industry. Imbedded in the flutes are carved cylindrical rods that represent the spindles found in Greenville's mill machinery. The city's chief commodity is reflected in the pairs of opened cotton bolls falling down from the scrolled volutes in the capitals. The columns span second and third (courtroom) levels surmounted by a cornice with "Greenville County Courthouse" engraved in stone.

The most famous (and infamous) trial of this courthouse came in 1947. Historian A.V. Huff relates that on the night of

February 17, a Caucasian taxi driver named Thomas W. Brown gave a twenty-four-year-old African American named Willie Earle a ride out to his mother's house near Liberty. Brown was later found fatally wounded in his cab and Earle was arrested and taken to the Pickens County Jail. Friends of Brown decided to take the law into their own hands and went to the jail to get Willie Earle. Unbelievably, the jailer released Earle to the armed men (mostly taxi drivers), who proceeded to take the man out to Bramlett Road and hang him from a tree. The event drew national attention when thirty-one men were brought to the courthouse to be tried for lynching Willie Earle. The building was equipped with a "colored" entrance, installed in the southeast corner facing West Court Street, which led directly upstairs to the separated balcony viewing space. African Americans anxiously awaited the verdict from the courtroom balcony. Even though the men admitted to the crime, the all-white jury found them not guilty. Though it was the last racial lynching of this type in the state, the event lit a fire in the African American community to fight for their civil rights. The agitated racial climate caused by the verdict was the environment in which a six-year-old local boy named Jesse Jackson grew up. He would later become one of the most influential civil rights activists in American history.

When the new (current) county courthouse opened on East North Street in 1950, the building remained as a family courthouse. With new space available in the building, the forerunning organizations of the Greenville County Museum of Art took up residence in 1951. The city's leading art organizations, Greenville Fine Arts League and the Greenville Art Association, came together to mount exhibits and teach art classes until 1958.

A few decades later, an interesting story happened involving the Weather Bureau of Greenville, which was then housed on the top floor of the back tower. A *Greenville News* (and later *Reader's Digest*) report explained that the Weather Bureau's instruments were located across the street on the roof of the taller Liberty Life Building. One night a man went to take the routine weather readings and the heavy door closed and locked behind him. At ten stories high, the man's cries for help went unheard and the freezing rain caused him to panic. He eventually came up with an escape plan by scribbling down a desperate note for help and dropping it over the side of the building with the weight of a nail. After more anxious waiting, the door finally opened through the fortunate efforts of a passerby.

After the family court moved to its new facilities on University Ridge (site of the old Furman campus) in 1991, the vacant building went into further decline. The architectural, planning and engineering firm of DesignStrategies resurrected the building as its new headquarters with a major renovation in 2002–03.

7. Chamber of Commerce/Liberty Building

The site of the Liberty Building on Court Square holds an important position in the history of Greenville. Only two structures are ever known to have stood here. When Lemuel Alston laid out the plat for Pleasantburg in 1797, the property where the Liberty Building now stands was planned as a street for public use to lead down to the city gaol (jail). In 1822–23 the new Greenville County Courthouse was built on this site (see page 110). It was designed by architect Robert Mills, who

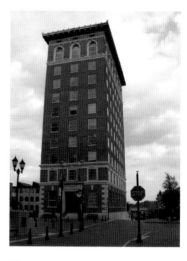

The ten-story skyscraper referred to by locals as the Liberty Building was built in 1925 as the Chamber of Commerce Building.

would later be known as America's greatest early architect. As the building approached its century mark, high maintenance and difficulty with modification caused officials to make way for the "progress" of the building boom of the 1920s. According to Henry McKoy, the Record Building (as it was then called) was coated entirely with a bright purple paint for the last several years of its existence. What makes this even more remarkable was that the law office building directly to the right of the Record Building was called the Blue Building and was painted entirely blue. As a result, Greenville at one time had the beginnings of its own Rainbow Row! In spite of its historical significance and classical beauty, the Record Building was demolished exactly one hundred years after its erection to make way for the chamber of commerce.

In the first two decades of the twentieth century, Greenville's textile-driven "New South" economy was causing a flurry of new buildings, especially skyscrapers around Court Square. Just off the Square on West Court Street, the four-story Carolina Supply Co. Building was built in 1914. The new county courthouse across the street from the Records Building was under construction from 1916 to 1918. A few blocks north saw the completion of the seventeen-story Woodside Building in 1923. Bricks, steel and other building supplies must have caused quite a few headaches from traffic and noise during those years. The Poinsett Hotel and the new Chamber of Commerce Building were simultaneously being built on the square during 1924–25.

The chamber skyscraper was planned to be finished in 1924 (the stone surround on the entryway even bears the date MCMXXIV), but contractor problems caused delays that pushed back the opening until 1925, at a cost of about $250,000. Beacham & Legrand designed the ten-story building and J.E. Sirrine & Co. was the engineer. Mintor-Homes Company started the construction and Potter-Shackleford Co. finished the job after the former went bankrupt. Large stone quoins set off the corners of the first floor, while the impressive metal cornice roofline accentuates the top of the building with a large overhang.

The chamber had great ambition to ride the tide of the swelling economy with its impressive new building, though it was unable to weather the storm caused by the Great Depression. However, one local business, Liberty Life Insurance Co., grew strong during those tough years and took over the Chamber of Commerce Building in 1931. Liberty established the insurance industry as a driving force in Greenville's economy, followed by others such as Canal Insurance Co. and Equity Life and Annuity Co. locating their headquarters here. Under the visionary leadership of successive members of the Hipp family, Liberty became one of the top insurance companies in the nation. It is one of the most successful homegrown businesses in Greenville history. Because the prominent company was associated with this building for several generations, it is locally referred to as the Liberty Building. Though the Liberty Corp. was bought out in recent years, the city is peppered with landmarks that have their names associated with it. Besides the Liberty Building, the old-time clock in front of the building and the Liberty Bridge honor the company's name through its generous donations for the beautification of the city.

Liberty outgrew the building by 1968 and moved into its new office complex on Wade Hampton Boulevard (then the largest office complex in the state). Meanwhile, the old chamber building was leased until it was sold in 1977 and given to North Greenville College to hold downtown classes. Needed improvements came in 1983 from Atlanta investors, and five years later the building underwent further renovations. In recent years it was bought by textile President Mark Kent, who has brought further updates to the building.

An institution of higher learning returned to the building in 2007 with Clemson University's establishment of its Renaissance Center on the sixth floor. This innovative venture establishes a vital presence for Clemson in the thriving downtown Greenville environment. The center is a division of its College of Business and Behavioral Science and is an incubator to inspire and develop entrepreneurship, innovation and leadership.

8. John Wesley United Methodist Church

The history of the John Wesley United Methodist Church perhaps encompasses the African American history of Greenville more than any other existing building in the city. The story begins with Wilson Cooke and James Rosemond, former slaves of Vardry McBee, the most important Greenville businessman in the city's early history. Cooke worked as a skilled laborer for McBee and purchased property and a home on West Coffee Street at the conclusion of the war. The origins of the John Wesley congregation date back to this time, when local African Americans exercised their new freedoms by organizing their own Methodist church. In 1866 a meeting was held in Wilson Cooke's home to organize the Silver Hill Methodist Episcopal Church with twelve charter members. James R. Rosemond, a preacher to slaves in the region before the war, is credited with the founding of Silver Hill Church.

Services were initially held in the Greenville Methodist Church (later known as Buncombe Street Methodist Church) on the corner of Church and East Coffee Streets until they decided to affiliate with the Northern Methodist denomination. Services were subsequently held in an old log building on Ann Street before moving to the congregation's first dedicated building (built with church funds) at the corner of Choice Avenue and Cleveland Street. The land was acquired from Alexander

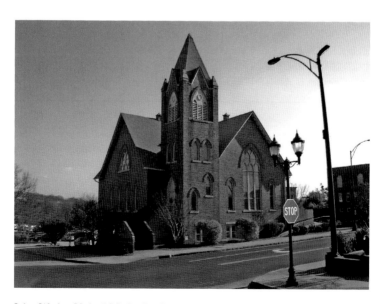

John Wesley United Methodist Church is Greenville's oldest African American church, with a rich history dating back to 1866. The current church was built in 1900.

McBee, son of Vardry McBee, who supported one of the church's founders, Wilson Cooke. In the early 1890s, Silver Hill appointed Reverend D.M. Minus to pastor and lead the effort to build a bigger church building. Not only was he able to do this, but in 1896 Minus also established Greenville's first African American high school, Greenville Academy, in the lecture room at Silver Hill. The school would later be reorganized as Sterling High School, whose graduates included Jesse Jackson.

On the southeast corner of East Court and Falls Streets a site for the new church was purchased for $1,200. Reverend D.M. Minus laid the brick foundation in 1899. After four years of building, the church was dedicated as the John Wesley Methodist Episcopal Church by Reverend B.F. Witherspoon, its first pastor. The three-story church is decorated with lancet arch windows filled with beautiful stained glass with Gothic tracery. The opalescent glass used in the windows was an American innovation and was in popular use at the turn of the century. Inside, the sanctuary is in the form of a Greek cross. The bell tower holds the main entrance and rises up four stories high.

When the Methodist denominations came together in 1939, the church was renamed the John Wesley Methodist Church. One of its notable members in these years was Hattie Logan Duckett, whose Phillis Wheatley Center building was constructed around the corner on Broad Street in 1922. Additional denomination restructuring in 1968 caused another name change to the current John Wesley United Methodist Church.

Further ties to local African American history include the church's use as a meeting place for Jesse Jackson's civil rights PUSH organization. Today the church is listed on the National Register of Historical Places and remains the city's oldest running African American church.

9. American Cigar Factory

The site of the cigar factory occupies lots 10 and 11 of the original town plan laid out by Lemuel Alston in 1797. Several homes must have stood on the property before a blacksmith built his shop on the corner of East Court and Falls Streets by the mid-1880s. A mule shed was added by 1888 on the site where the American Cigar Factory would be built. By then the street became a thoroughfare for businessmen to haul their goods to the freight warehouse and depot at the end of the railroad line just to the east.

At the turn of the century, Greenville's economy was dominated by textiles. Local leaders looked to the burgeoning cigar industry to expand the city's business profile and contracted J.E. Sirrine

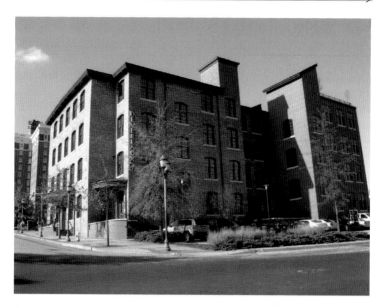

The American Cigar Company factory was built in 1903 and later housed one of Greenville's greatest homegrown businesses, Stone Manufacturing.

to build a large brick building on the northwest corner of East Court and Falls Streets in 1903 (a year later the Salvation Army opened its Greenville work in a tent next to the cigar factory). The four-story building was 137 feet by 60 feet and was one of the largest structures in the city at the time (the Camperdown and Huguenot Mills were only two stories). The American Cigar Company came to Greenville with high expectations from locals. Besides diversifying Greenville's economy, the factory also opened up employment for hundreds of women to hand roll the cigars. Soon after opening, employees reached an astounding output of nearly half a million cigars per week. By 1909, the City Directory lists that Seidenberg & Co. took over the facility. The Seidenbergs began their company in Key West and were the first to import tobacco into the United States and manufacture Havana cigars.

After almost three decades of production, financial difficulties brought on by the Great Depression caused the factory to shut down. Soon the Piedmont Shirt Company moved in, bringing the building into the realm of the city's buoyant textile industry. Apparel production continued a decade later when Stone Manufacturing took over the building. Stone is another of Greenville's great homegrown success stories, so it is worth noting how this business grew and this building's place in its history. Eugene E. Stone III started the company in 1933 at the age of twenty-one while the country was still in the midst of the Depression. He opened up on the second floor of a River Street

warehouse, producing children's clothing with just a handful of employees and sewing machines. Growing demand caused the company to relocate to larger facilities in the old cigar factory in 1942. A new line of children's sunsuits was added after moving into the East Court Street facility. Within four years, Stone Manufacturing was the largest manufacturer of the product in the world. In the same year the company moved into the old cigar factory it also established two more Greenville plants and one in Columbia.

As the business continued to grow, it needed to relocate to a new, larger facility. Furthermore, the working conditions at the old cigar factory were extremely difficult in the summer heat—as they had been for local textile mills since their inception. Stone's new facility at Webster and Calvin Streets in 1948 became the first air-conditioned and heated garment factory in the city. Maxon Shirt Corp took over the East Court Street plant for a number of years until Stone Manufacturing reoccupied it in 1958 with needs for additional production facilities. Stoneswear products were sold all over the nation as well as in overseas markets. By 1975, Stone ran eleven factories employing 3,500 people in South Carolina and Georgia. Production branched out to playwear and sleepwear for ladies and children, lingerie, sportswear, men's dress shirts and underwear. With over 500,000 pairs a week, Stone was the world leader in underwear production.

Stone's Cherrydale plant (located where Cherrydale Mall now stands) was at one time the largest apparel plant in the world under one roof. In 1981, the company bought the Umbro sportswear line and pushed the company to even greater international dominance in the apparel field. The Cherrydale plant was the U.S. headquarters and distribution center for Umbro's soccer equipment and clothing division. Umbro offices were located in the old cigar factory after a quarter-million-dollar renovation. Stone sold Umbro for $145 million in 1999 and later was sold to Nike in 2007 for $582 million. It's amazing what can develop from determination and a few sewing machines.

The old cigar factory was vacated in 1994. Three years later, textile mogul Mark Kent bought it and invested over $4 million in renovations. Today the building (with modern additions) is on the National Register of Historic Places and houses office and restaurant space.

10. Vardry McBee Statue

If any single person could be identified with Greenville's initial prosperity, it would be the man represented in this statue, Vardry McBee (1775–1864). Vardry, a Quaker, was born in what is now

Cherokee County to parents who were among the first settlers of South Carolina's northwest. He spent most of his years growing up in Lincolnton, North Carolina, learning the trade of a saddle maker. In 1815, Vardry expanded his business horizons by purchasing 11,028 acres from Lemuel Alston in Greenville, South Carolina. He paid $27,500 for the land and his North Carolina friends thought he was foolish for making such a purchase. Vardry took a calculated risk that he was confident would pay off, and it did. Soon land in Greenville that he had paid $2 to $3 an acre for was reselling for $200 to $300 per acre—quite a turnaround on his investment.

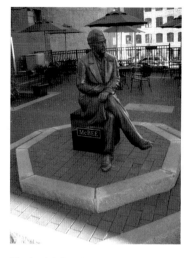

Vardry McBee is considered the "Father of Greenville," primarily for the economic and philanthropic contributions he made in its crucial early years.

For Vardry McBee, the city was his investment—literally. He was instantly the largest landowner in town and set out to diversify his business portfolio to an extent unmatched by any other nineteenth-century Greenvillian. Some of his businesses in Greenville and the region included a gold mine, ironworks, cotton mill, paper factory, a foundry, rolling mill, rock quarry, brickyard, gristmills, general stores, tanneries, sawmills and saddleries. He is said to have been behind the construction of over one hundred buildings in what was then the Greenville District.

Perhaps outshining McBee's great commercial contribution to the city was his unending philanthropic activity. His focus was on two of the great pillars of Greenville society—education and religion. When McBee bought his Greenville land in 1815, there still were no formal schools (only "free schools") organized for local youth. Some of the primary factors for any school's foundation are getting past the hurdle of where to locate it and what construction costs will be. McBee helped organizers save a bundle of money for the "where" by donating all of the land for the schools. Thirty acres were given in 1820 for the establishment of the Greenville Academy (with separate boys' and girls' facilities) in the northwest section of present-day downtown, now referred to as Heritage Green. In fact, the name of Academy Street is a little-known reminder of the city's first schools.

When Furman University was looking to relocate out of Winnsboro, it was Vardry McBee who played a crucial role in its decision to come to Greenville in 1851. One factor involved the promise of a prime tract of land overlooking the Reedy River. McBee could have sold the land to the railroad looking to locate a station for the new line (Greenville's first) from Columbia. However, he sold the land to Furman at a 50 percent discount and sealed the deal to bring the university here.

Sometimes Greenville is called the "buckle of the Bible belt" because of its proliferation of churches, along with historically conservative institutions and societies. The origins of its Christian heritage go back to when Vardry McBee donated or sold land for all four of Greenville's original church denominations. In 1820, St. James Mission of the Episcopal Church (now Christ Church Episcopal) was the first to organize on four acres of land bordering the east side of Church Street. Next came a 120-square-foot lot for the Baptists' first church. Methodists built on a 100- by 120-foot plot on East Coffee Street. Presbyterians received a lot on the west side of Richardson Street. Ten years after Vardry McBee died, his son donated one acre of land for the building of the first Roman Catholic Church in the city. McBee also donated lumber from his sawmill to help erect the churches. For these and many other reasons, Vardry McBee is

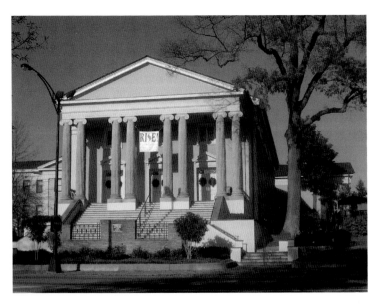

Buncombe Street United Methodist Church was built in 1873 as the congregation's second church building. On dedication day, the pastor locked the doors and no one could leave until the debt was paid off. People gave and were set free!

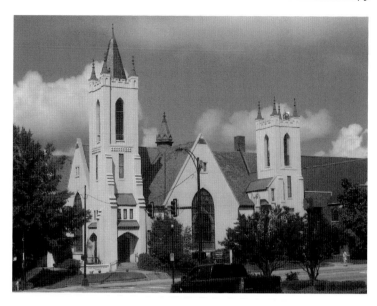

The original section of First Presbyterian Church's current building was built in 1883 and has expanded greatly over the years.

called the "Father of Greenville." He is buried in the Christ Church Episcopal Cemetery in downtown Greenville.

The life-size bronze statue depicting McBee was created by sculptor T.J. Dixon of San Diego, California, and was dedicated on June 26, 2002.

11. Joel R. Poinsett Statue

Joel Roberts Poinsett was born in 1779 in the historic city of Charles Town, South Carolina, but had the means and ambition to travel the world. His early childhood was spent in England before returning to attend a private school in Greenfield Hill, Connecticut, at age nine. Further educational opportunities brought him back to England, including training at a military school.

Poinsett returned briefly to Charleston in 1800 to study law before returning to Europe to travel, ultimately gaining entrance into the courts of Napoleon in France and Tsar Alexander I in Russia. After returning to America in 1809, he was enlisted by President Madison to go to Argentina and encourage a revolution against Spain. He then went to Chile to help set up an American-modeled constitution.

Shortly after returning to America, he was elected to the South Carolina House of Representatives from 1816 to 1820.

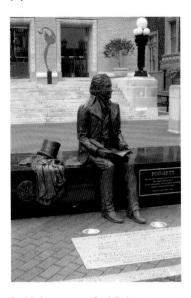

In his later years, Joel Poinsett spent his summers in Greenville and was an active member of Christ Church Episcopal.

At the end of his term, Poinsett became head of the South Carolina Board of Public Works, overseeing the building of the state road (near Greenville) into the North Carolina mountains. An attractive stone bridge named in his honor remains today not far from Greenville at Gap Creek. At the foot of Saluda Mountain, a spring near the road offered travelers and road workers cool water. A stone fountain was erected to make a convenient "rest stop" for refreshment long before restaurants, coffee houses, gas stations and lavatories came to state highways. A later owner of the land donated the fountain (though it still belongs to the state) to the Poinsett Hotel and it was installed in a small city park beside the hotel. When the hotel was restored in 2000, the fountain was removed for safekeeping and currently resides in the corner of Court Square diagonally across from the hotel. The initials J.R.P. with the date 1820 are engraved on the front side, while across the back a piece of white marble bears the name "Poinsett Spring."

Poinsett was elected to Congress after his short term serving in the Public Works department. Four years later, President Andrew Jackson chose him to be the first U.S. ambassador to Mexico, which had recently gained independence from Spain. In spite of his impressive political career, Poinsett would long be remembered more for bringing back a red wildflower from Mexico named in his honor—the popular Christmas "poinsettia."

His return to South Carolina brought another (short) term in the state legislature, where he took up the Unionist cause in the growing nullification controversy. Starting in 1834, he began spending his summers in Greenville at a home built near the present-day White Horse Road. His long resume was expanded with another presidential appointment as Van Buren's secretary of war in 1837. In spite of his demanding responsibilities in Washington, D.C., Poinsett continued to return to Greenville and participate in local concerns. Retirement from public office in 1841 allowed him to focus on such things as serving on Christ Church Episcopal's vestry. On his way traveling back

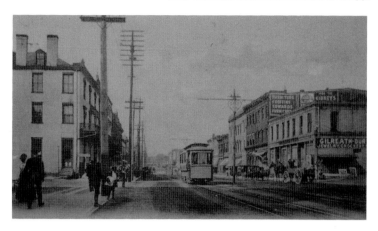

Here is a late nineteenth-century view of Main Street from Court Square looking north from where the statue of Joel Poinsett now stands. *Courtesy of the Greenville County Library System.*

to Greenville, Poinsett fell ill and died in Statesburg, South Carolina, on December 12, 1851. The life-size bronze statue honoring him was created by a local Greenville sculptor, Zan Wells, and was dedicated on December 1, 2001.

12. Poinsett Hotel

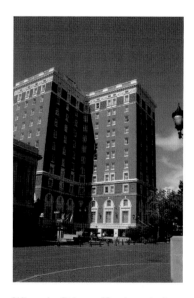

The site of the Westin Poinsett Hotel has one of the most significant histories since the village plan was first laid out in 1797. Only two commercial structures have ever been known to be located there—both prominent hotels known throughout the South for their top-notch accommodations. One year after Greenville was chartered as a town (1823), Colonel William Toney bought property on the northwest corner of Court Square to construct a comfortable and exquisite hotel especially suited to the upscale tastes of the growing number of Charleston summer residents. To help meet this need, he

When the Poinsett Hotel was built in 1925, it was touted as "Carolina's Finest." A $25 million renovation reopened the hotel in 2000 and it has been beautifully resurrected as "Carolina's Finest."

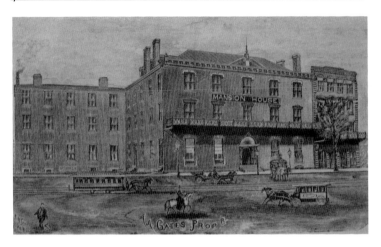

The Mansion House was Greenville's premier hotel before it was torn down a century later to make way for Greenville's current premier historic hotel—the Westin Poinsett. Notice the horse-drawn trolley going down Main Street in front of the building. *Courtesy of the Greenville County Library System.*

even used Charleston contractor William Bell to design the structure. Perhaps fellow Charlestonian architect Robert Mills, who designed the county courthouse being built across the street, made the suggestion for the job. The three-story brick building wrapped around the corner of the grassy Court Square into an L shape and was named the Mansion House.

Over the next half century, whenever notable guests would visit Greenville they would be sure to stay at the Mansion House. John C. Calhoun, vice president of the United States under Adams and Jackson, is remembered to have preferred a room on the second floor during his visits to Greenville. Benjamin Perry moved to the city in 1823 to attend the Greenville Academy and soon made his accommodations in the Mansion House until he was married in 1837. Governor Wade Hampton also used the hotel when he came to town. Furthermore, visiting preachers would use the hotel as a gathering place to speak before some of the local churches were built.

When Camp Wetherill was created in Greenville during the Spanish-American War, the Mansion House was enlisted for military use as a division headquarters and officer housing. By that time the hotel was getting pretty old and the facilities were outdated. Within the next decade the new Ottaray Hotel was built on the north end of Main Street and the Mansion House was no longer the long-standing favorite in town. In its last decade, attempts were made to resurrect the hotel but retail establishments took over before it was finally demolished in 1924—exactly a century after it was built.

Such a historic hotel could only be satisfactorily replaced by one that was even grander than before. And so it was. The Poinsett Hotel was erected on the same site with the L-shaped design of its predecessor. As Greenville grew in prominence in the textile industry, mill owners with capital and ambition found ways to contribute to Greenville's quality of life while also making a profit. Such is the case with the building of the Poinsett Hotel. The coming of the biennial Textile Exposition to Greenville in 1915 highlighted the city's dire need for accommodations. Nearly forty thousand people attended the first weeklong exhibit while the City Directory estimated a population of only thirty-four thousand with just five hotels. Many people had to be put up in private homes to fill the need. The Ottaray and Imperial Hotels were fairly new and held hundreds of people, but hotels were desperately needed to meet the impending demand.

The Poinsett Hotel was conceived to fill the city's need for hotel space—but not just in any ordinary way. John T. Woodside and William Goldsmith joined forces to build the hotel in the heart of downtown. As soon as the Mansion House was razed, groundbreaking commenced at the same time the new chamber of commerce ten-story skyscraper was being built across the street. Not to be outdone, the Poinsett (named in honor of former Greenville resident Joel R. Poinsett) would rise to twelve stories high. John Woodside's involvement in this project was just one of many that propelled him to be one of Greenville's most notable businessmen in its history. When construction began on the Poinsett Hotel, work had recently finished on the seventeen-story Woodside Building on the next block north. This impressive building was the tallest skyscraper in the state at the time it was built. On the heels of finishing the Poinsett, Woodside set out to build a "playground for millionaires" in Myrtle Beach called the Ocean Forest Hotel and Country Club. The primary source for financing these ambitious projects was the Woodside Cotton Mill that John founded with his brothers. The mill grew to be the largest mill under one roof in the entire nation.

Returning to the Poinsett Hotel, the choice of New York architect J.L. Stoddard was part of the overall goal of giving Greenville a monument that would draw attention and endure in the quality of its design. Just as ground broke for the hotel in May 1924, Stoddard's new twelve-story Francis Marion Hotel had just opened in Charleston. A local favorite, J.E. Sirrine & Co., was chosen as the engineer. After about a year of construction, the $1.5 million hotel (same cost as the Francis Marion) opened in June 1925. A grand lobby and staircase surrounded by marble and decorative wrought iron welcomed guests on their way to the one hundred guest rooms. Perhaps the most impressive features

were the grand ballroom in the front section of the building and the convention hall in the back. Shortly after opening, the hotel was considered by many as "Carolina's finest."

The hotel's heyday came in the 1940s and '50s under the leadership of the acclaimed hotel manager J. Mason Alexander. The formula of his success is said to have been his adherence to the "Four Cs: cleanliness, cooking, competency and courtesy." An example of the cleanliness he demanded is found in the way money was handled at the hotel. Fresh new bills were brought in daily from the bank and guests received only crisp one- and five-dollar bills. Coins were washed in a coin washing machine to make them always appear clean and new. As for cooking, the hotel's exquisite dining room became a local favorite, especially for its signature spoon bread. The highest competency was expected at all staff levels, especially down to the bellhops and clerks, who were the frontline source of hospitality. When guests checked in, the clerk wrote their names on pieces of paper and slipped them to the bellhop who showed the guests to their rooms. Between the time the guests left the lobby and arrived at their rooms, the bellhop was required to use their names three times. (In his youth, Jesse Jackson was a bellhop at the Poinsett.) As for courtesy, a detail in this respect was the free stamps found in the drawer of each guest room. It is no wonder that in 1946 the Poinsett was voted the best midsized hotel in America by the American Hotel Association.

Some of the notable guests who stayed at the hotel in its early days include Amelia Earhart, John Barrymore, Jack Dempsey, Gloria Swanson, Cornelius Vanderbilt, Mrs. Calvin Coolidge, Bobby Kennedy and Liberace. Motel chain operator Jack Tar bought the Poinsett in 1959 and the hotel went into decline over the next few decades. A new owner made $1 million in renovations in 1973 but closed the hotel two years later for financial difficulties. In 1977, the building became a retirement hotel until it closed once again a decade later. The hurdles for the Poinsett were too great to overcome and the abandoned hotel became derelict and condemned in 1987.

In the late 1990s, an interesting sequence of events took place in the revitalization of the Poinsett. Looking back to 1924, the Francis Marion had opened under the design of J.L. Stoddard. Seventy-two years later, the hotel reopened after a full restoration by investors Steve Dopp and Greg Lenox. The Poinsett Hotel opened in 1925 under the design of the same architect and was bought by the same investors seventy-two years later to do a full restoration. After a $25 million investment, the Poinsett Hotel, now under the Westin name, reopened in 2000 to great fanfare and critical acclaim. Many of its original details were preserved, including the tile floors that were originally installed by the

local Campbell Tile Co., which also did the restoration. The Poinsett Hotel brings a period charm to Greenville that reflects its prosperity in the 1920s as well as the 2000s.

Today the Poinsett is the only four-star rated hotel in the Upstate and reigns as downtown's "star gazing" destination. Often the internationally renowned performers from the Peace Center will stay at the hotel when they are in town. Some of the celebrity guests in recent years include Lance Armstrong, Sheryl Crow, Johnny Bench, Maury Povich, Jim Rice, George Rogers, Jamie Farr, Larry Holmes, Wanda Sykes, Senator Joe Lieberman, John O'Hurley, Tommy Lasorda and Aretha Franklin. The "Four Cs" of the hotel's early success continue in new applications during its present success.

13. First National Bank

The southwest corner of McBee Avenue and Main Street is home to the most important history of banking in Greenville. Early history of the lot goes back to the mid-1800s, when Hastie Nicol ran a dry goods store; he later sold it to Fountain Fox Beattie in 1854. F.F. Beattie's son, Hamlin, took over the dry goods business under the name H. Beattie & Co. His likeable personality and generous nature helped the business to thrive and gain the confidence and respect of its patrons.

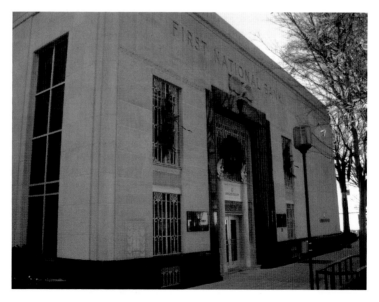

The impressive Art Deco façade of First National Bank (1938) is the best example of the style remaining in downtown Greenville.

There were no pre–Civil War banks in Greenville, so money was exchanged and borrowed from local merchants. In a history of this banking site, Judy Bainbridge writes that Hamlin Beattie worked out a system with the Bank of Charleston to allow Greenvillians to make drafts through his store rather than travel all the way to the coast. This successful arrangement provided the confidence needed for Charleston bankers to send about $30,000 to Beattie to avoid Sherman's potential robbing of the funds as he advanced on the city. During the entire war, Greenville never had any direct fighting in its borders. Surely it was a safer place than Charleston; or so bankers thought.

Greenville's first and last brush with Union aggression actually came three weeks after Robert E. Lee surrendered at Appomattox. Believing that Jefferson Davis may be fleeing south through Greenville, Union army Brigadier General George Stoneman dispatched a cavalry to look for Davis throughout the region. On May 2, 1865, a band of soldiers under Major James Lawson rode into town on orders from Stoneman to pursue Davis "to the ends of the earth." Stores were raided, a home was set on fire and a local man was killed as the men searched for arms, horses and (in vain) Jefferson Davis. What they did find was the Charleston bank money hidden behind a wall in Hamlin Beattie's dry goods store here on the corner of McBee Avenue and Main Street. The event became known as "Stoneman's Raid" in local lore.

Beattie fared far better economically than most Greenville businessmen after the Civil War. He wanted to start a formal bank and received a charter with other investors for the First National Bank in 1872. It was the first national bank to be chartered in the entire state. Its initial location was at the Goodlett House a block north, but a year later the bank moved into a new building on Main Street just south of Beattie's dry goods store. In 1917, an impressive new Beaux-Arts style bank was built over the site of the dry goods store to house the rechartered First National Bank of Greenville. Its limestone exterior was pierced by two-story arched windows and the main entrance was flanked by a pair of large carved stone eagles. Twenty years later, the bank completely renovated a building in the lot next door in the Art Deco architectural style made popular in the late 1920s. The former bank building on the corner was reused as various restaurants until the bank extended its Art Deco façade to cover it up.

The expansion and success of First National brought on a merger with the state's largest bank, South Carolina National Bank (SCNB). A year later the SCNB relocated, but the site continued to be used by several other financial institutions from 1959 to 1973 before First National of South Carolina

took over the building. After a brief nonfinancial tenant in the mid-1980s, the building was once again used as a bank when the newly formed Carolina First Corp. bought it and began renovation in 1987. Carolina First had been formed by local Greenvillian Mack Whittle a year earlier with initial assets of $15 million. Within nine years, assets grew to over $1 billion after the successive acquisitions of many smaller banks. Whittle expanded out of state and reorganized Carolina First as a subsidiary of the South Financial Group, once one of the leading banks in the nation. The bank's commitment to and financial investment in Greenville has continued with such announcements as the underwriting of the former Palmetto Expo Center that now bears its name, the Carolina First Center.

14. Prospect Hill

The history of Prospect Hill goes back to the late eighteenth century, when the village of Greenville consisted of a few public structures and scattered houses. On the first day of South Carolina's new land grant law in 1784, Colonel Thomas Brandon of Union District, one of many land speculators who surfaced after the Revolution, bought all of the land formerly

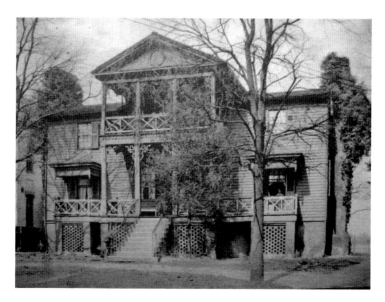

Prospect Hill is the historic homesite of Lemuel Alston, the man responsible for laying out the first village plat in 1797. The wooden house was built in the late eighteenth century and later served as Vardry McBee's residence. *Courtesy of the Greenville County Library System.*

owned by Greenville's first colonial settler, Richard Pearis. Pearis, a Loyalist, had all his lands confiscated by the new state government. In 1788, Lemuel Alston purchased 11,028 acres (including Thomas Brandon's land) encompassing the entire area of what would become downtown Greenville. He built a two-story wooden mansion on a swell in the land overlooking the city from the west and named it Prospect Hill. Later newspaper accounts record that the clapboard-covered log house had two bedrooms on the first floor and four on the second.

Alston's hopes for land sales in Greenville did not meet his expectations (neither did his run for reelection to the South Carolina Congress), so he sold his land and moved to Alabama. Vardry McBee bought all of Alston's land, including his home, for $27,550 in 1815. A.V. Huff writes that in the same year McBee bought Prospect Hill, it was leased to Edmund Waddell, who turned the six-bedroom house into a hotel. It was the village's first documented hotel, a number of which were built in the next decades specifically to house summer residents from Charleston. The most elegant and long-lasting was the Mansion House at Court Square. The Goodlett House at the corner of Washington and Main Streets also served many travelers. Resorts with healthful springs also became regional attractions. The most notable of these was Dr. Burwell Chick's large and scenic Chick Springs resort and hotel in Taylors.

When Vardry McBee finally moved to Greenville from Lincolnton in 1836, he returned the Prospect Hill hotel back into a residence that he would live in until his death in 1864. A year after Vardry's death, the property was bought by John Westfield, who is remembered by the street that runs across the hill.

By the mid-nineteenth century, Chick Springs resort in Taylors became one of the most popular summer retreats in South Carolina. *Courtesy of the Greenville County Library System.*

The next phase of Prospect Hill's role in Greenville's history came in 1888, when the city purchased part of the property to serve its educational needs. Central School was one of the first public schools of the new City School District of Greenville created under an act of the state legislature. The all-white Central School brought in students on one side of the Reedy River, while the West End's Oaklawn School served those on the other side. African American children attended Allen School and within a decade Reverend D.M. Minus at the Silver Hill Methodist Episcopal Church (now John Wesley United Methodist) started Greenville Academy.

Another significant educational milestone for the site happened when Central School became the city's first high school. The original building was torn down in 1920 (along with Lemuel Alston's historic but dilapidated home) to make way for a larger and improved school. When another new facility (Greenville High School) was built on Augusta Road in 1936, what was Central School became Greenville Junior High for the next thirty-one years. Sterling High School moved in for three years after its facilities burned down in 1967. The obelisk monument was erected in 1988 to commemorate Prospect Hill's role in the city's history.

In 1991, the 43,000-square-foot, Colonial-style Greenville Water System headquarters was built on this historic hill. The attractive brick building is loosely modeled on the historic capitol building in Williamsburg, Virginia.

15. Textile Hall

In the early twentieth century, Greenville's textile industry was putting the city on the map in a way that had only been hinted at previously with the success of the carriage-making industry of the Gower, Cox and Markley Carriage Factory. Indicators of its success were dozens of mills, the presence of forty-three mill presidents who called Greenville home and 10 percent of the supplies for the entire national industry were purchased in the city. Prior to the 1900s, New England had always held the leadership position in textiles. Textile expositions were the "World's Fair" events of the industry to show off the newest and best machinery and supplies to eager crowds of thousands. Boston was the sole location for textile expositions until enterprising Greenville businessmen sought to capitalize on the shift of power to the Southern states. It became apparent that a city in the midst of the large sector of Southern manufacturing needed to host the expositions. Greenville was the clear hub of the textile scene after the first decade of the century—second

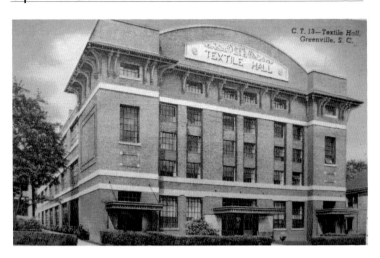

For many years, Textile Hall hosted one of the biggest expositions in the South. *Courtesy of the Greenville County Library System.*

nationally only to Massachusetts. In 1914, the Southern Textile Exposition, Inc. was formed to push the event to fruition. The city was set to host the first Southern Textile Exposition on November 2–6, 1915, with expectations of a strong regional turnout. Word spread about the event, World War I concerns calmed and interest poured in from across the South and North. Before the show opened, the amount of booked exhibit space was four times higher than anticipated by the organizers.

The event was held in the vacant warehouses of the Piedmont & Northern Railroad on the southwestern corner of Academy and West Washington Streets. Organizers made do with the less than favorable facilities, but the turnout indicated that great things were ahead. The inaugural attendance of nearly 40,000 visitors to see a fully booked array of 169 exhibitors ignited organizers to plan for the next show with bigger and better plans. The Southern Textile Exposition, Inc. set out to meet the demands by erecting a dedicated building on West Washington Street (across from the P&N warehouses) to house the ongoing event. J.E. Sirrine, who was on the original exposition committee, planned and built a new forty-thousand-square-foot facility for $130,000 to be ready for the next show on December 10, 1917. Exhibitors displayed standard and improved machinery, textile accessories, building and operating supplies, fabricating materials and more. The success of the show's Cinderella event two years earlier was confirmed with another blockbuster turnout at the new Textile Hall (despite the fact that the building wasn't even quite finished).

The show was held every other year with enough steady growth that a fourteen-thousand-square-foot annex was added

by 1930. Besides textile shows, Textile Hall also hosted events for regional cultural, religious, charitable and educational groups. The annual Cotton Festival and Southern Basketball tournament were examples of regularly scheduled events that drew large numbers of people to the city. Concerts with the likes of John Philip Sousa and his band also performed here. The highest attendance for the Southern Textile Exposition happened in 1956, when over 40,000 viewed the displays of 330 exhibitors.

Eventually twenty-two Southern Textile Expositions were held on West Washington Street. By the mid-1960s, expansion beyond the original hall and nine additional annexes (for a total of about 100,000 square feet) was not possible, so plans were made to build a new, much larger facility. In 1962, the last exposition in Textile Hall accommodated 450 exhibitors from thirty states and ten countries, with over 30,000 visitors in attendance. The new Piedmont Exposition Center (now Carolina First Center) off Pleasantburg Drive boasted 183,700 square feet of exhibit space on a 30-acre plot of land next to the Greenville Municipal Airport (recent renovations put it at 315,000 square feet). Just as the building of the 1917 Textile Hall signaled Greenville's position as the "Textile Center of the South," so the completion of the new textile expo center in 1964 heralded Greenville's status as the "Textile Center of the World."

In 1991, St. Mary's Catholic Church acquired the neighboring property occupied by Textile Hall and tore it down to make room for classrooms, office space and parking.

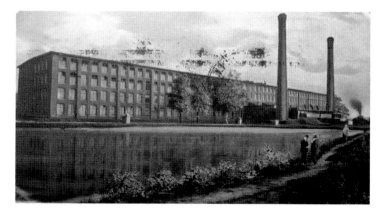

The large Poe Mill was one of most productive in Greenville's textile era. *Courtesy of the Greenville County Library System.*

16. Woodside Building

Though it is no longer here, the Woodside Building played a symbolic and historic role in the development of Greenville's textile boom. The 1920s saw new downtown construction on a scale only approached by the new college, church and courthouse buildings in the 1850s. The Woodside Building was the first tall skyscraper erected in the city, signaling a new era of architecture, civic pride and economic prosperity.

The patriarch of the family behind the Woodside Building was Dr. John L. Woodside. John and his wife Ellen brought up twelve children in southern Greenville County. The eldest child and one of nine boys was John T. Woodside. Over the years, several of the brothers would work together in the textile world, while another would find success in banking. In the first years

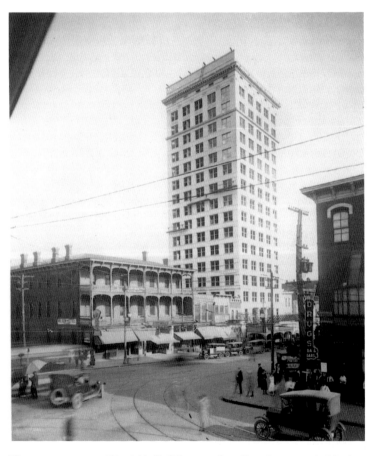

The seventeen-story Woodside Building was the tallest skyscraper in North or South Carolina when it was finished in 1923. *Courtesy of the Greenville County Historical Society.*

of the twentieth century, John T. Woodside claimed to have the best groceries in town at his shops at 134 Main Street and 110 McBee Avenue. John's prior work with the Reedy River Manufacturing Company combined with his grocery success to propel his ambition in the business world. The Woodside brothers' venture into the textile industry began in 1902 when John T. partnered with his brother J.D. to organize the Woodside Cotton Mills. Within twelve years of opening, the number of spindles increased from 11,000 to 112,000 and brought the distinction of making the mill the largest under one roof in the country. Other mill ventures included the buyout of the Fountain Inn Manufacturing Co. in 1906 and the organization of the Simpsonville Manufacturing Company two years later. To bring their family textile business to the next level, all three of their mills were united in 1911 to form the Woodside Cotton Mills Company.

Meanwhile, another brother in the Woodside clan, Robert, became successful in the financial sector and was president of the Farmers & Merchants Bank of Greenville by 1907. Similar to his brothers' ambition to assume local leadership in their field, Robert organized the Farmers Loan & Trust Company, the Home Building & Loan Association and the Woodside National Bank in 1919. The next year, Robert joined financial forces with his brothers to organize the Woodside Securities Company.

In a short time, plans were made to house the Woodside Securities Company in the tallest structure in the state. The

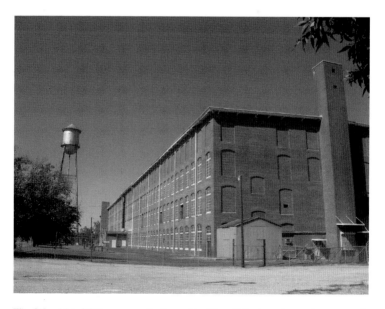

The Woodside Mill was once the largest textile mill in America under one roof.

seventeen-story white brick skyscraper was designed by New York architects and took nearly three years to build. Easley Mills was responsible for the construction and sought advice from the engineers of the Woolworth Tower in New York, which was the tallest building in the world at the time. The total cost of construction was estimated at $1.5 million (the same cost of the Poinsett Hotel a few years later). Ample interior space offered enough room for four hundred offices outfitted with mahogany woodwork. When it was discovered that the building was just shy of being the tallest in North and South Carolina, a parapet was added at the top to push the building into the record books. It held the distinction for three years until First National Bank built a taller headquarters in Charlotte, North Carolina.

One of the amusing stories during construction was reported by the *Greenville News*. In February 1921, a stuntman nicknamed "The Human Fly" advertised a spectacle event that would take him to the top of the recently finished twelfth-story steel framing. The man began his barehanded ascent when he was suddenly challenged by an amused structural ironworker who had already spent plenty of time skillfully maneuvering on the building's skeleton. The "Human Fly" accepted "Slim" Jones's offer to race him, to the delight of all who watched. Jones soundly defeated the "professional" climber and proceeded to taunt the humiliated man by performing stunts while waiting for him to arrive at the top. The joyful crowd was entertained far beyond what they thought they came to see and proceeded to pass around a collection hat for the triumphant ironworker.

The Woodside empire collapsed as a result of the devastating effects of the Great Depression. The building was bought in 1950 by South Carolina National Bank, which had already occupied most of the street-level floor. When the bank again sought a major move, the Woodside Building became a victim of progress with its demolition in 1975. SCNB built its own ten-story skyscraper on the same site as the Woodside Building (with additional property to the east). Wachovia Bank later took over SCNB and bears the current name, Wachovia Place. The complex includes 158,000 square feet of office space, luxury apartments, retail space and an attractive piazza/courtyard.

17. Sterling High School Statue

The origins of Sterling High School begin with the visionary leadership of Reverend Daniel Melton Minus. The primary mission of Minus's move to Greenville in the 1890s was to take over the pastorate of the city's earliest surviving African American church, Silver Hill Methodist Episcopal (soon to

be renamed John Wesley
Methodist Episcopal). Within
a few years, Minus's passion
grew to provide local African
American children with their
first high school. He proceeded
to spearhead the organization
of an educational committee,
finding funding and securing
the permits from the state to
open the school. His dream
became a reality with the
opening of the Greenville
Academy in 1896 in a humble
room at the Silver Hill Church.
Enrollment steadily increased
and more space was needed to
accommodate the growth.

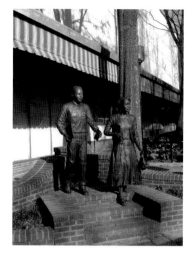

The bronze statue at the corner
of Washington and Main Streets
commemorates the legacy of
Sterling High School—Greenville's
first African American high school.

According to Ruth Ann
Butler, the school bought the
church building and remained
in it for several years until
trustees decided a new purpose-built structure should be
erected. Minus enlisted the financial and organizational help
of a number of Greenville's leading Caucasian businessmen, in
an unprecedented display of racial unity. The most important
contributor was Thomas Parker, who financed the building of
the new two-story school in west Greenville on the corner of
what would become Jenkins and Maloy Streets. With the move,
Greenville Academy was renamed Sterling Industrial College
to honor the name of the woman who had financed Reverend
Minus's education at Claflin University. Soon new streets and
an African American community developed around the school.

The school prospered in its early years under the leadership
of Reverend Minus and his successor, Carey Jones. However,
the school closed for a short time and was reused as Enoree
High School until 1929, when Greenville County bought the
building and returned the Sterling name as Sterling High
School. The rejuvenated institution went on to produce the
majority of Greenville's future African American leaders.

Joseph Allen Vaughn, Sterling's student body president,
became Furman University's first African American
undergraduate student admitted when the university
desegregated in 1965. He was embraced by the student body
and became an officer in the Baptist Student Union, vice-
president of the Southern Student Organizing Committee, a
sports cheerleader and a volunteer in the Collegiate Educational

Service Corps. He also organized and rallied fellow students in civil rights marches in downtown Greenville.

Jesse Jackson attended Sterling and became an honors student as well as the star quarterback for the football team. His talents were good enough to earn him a football scholarship to the University of Illinois in 1959. He went on to get involved as a civil rights activist before going to seminary in Chicago. Just before graduating, he left school to join Reverend Martin Luther King Jr.'s civil rights movement in Alabama. After the death of Dr. King, Jackson led a number of civil and economic rights organizations, including Operation PUSH and the National Rainbow Coalition. Jesse Jackson became the first African American to run for president of the United States in the 1984 race and again in 1988. Jackson continues to be an internationally known civil rights leader.

Other notable graduates of Sterling include Ruth Ann Butler, founder of the Greenville Cultural Exchange Center; Ralph Anderson, South Carolina senator; Lillian Brock Flemming, one of the first female African American Furman graduates and the first African American woman to serve on the Greenville County Council; and Xanthene Norris and Lottie Gibson, also both Greenville County Council members.

A significant chapter in Greenville's history closed when Sterling (except the gymnasium) was destroyed by a fire in 1967 and was dissolved three years later when Greenville County schools were integrated. Sterling's influence hasn't been forgotten in the local community, and starting in 2006 everyone who walked Greenville's bustling Main Street would remember too. On November 19, hundreds of people attended the dedication of this bronze statue on the northwest corner of Washington and Main Streets commemorating the legacy of Sterling High School. Two African American students are depicted proudly walking down the steps of the school. The boy wears an "S" on his sweater and the girl carries schoolbooks. Sculptor Mariah Kirby-Smith made the statue with funds raised from the Friends of Sterling. The location was chosen for the African American history that took place in the Woolworth's store formerly on this corner. Sterling High students and other members of the community gathered regularly at the store's lunch counter for peaceful civil rights sit-in demonstrations in the 1960s. Such events ultimately led to the integration of Greenville's public buildings. Sterling students also used to wait at the corner here for the bus to take them to school. Wilfred Walker, the school's oldest living teacher (ninety-four) at the time of the statue's erection, laid a symbolic brick in the monument wall. Fittingly, he had taught masonry, which was one of the many trade skills students could learn at the school.

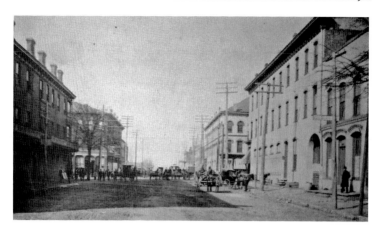

Here is a photo circa 1895 showing the intersection of Washington and Main Streets. The Sterling High School statue now stands on the corner to the upper right. *Courtesy of the Greenville County Library System.*

18. Uncle Sol's Pawn Shop/Carved Rooster

When this building was Uncle Sol's Pawn Shop, a carved rooster with a fascinating story was installed in the façade.

Somewhere on the top of a Main Street building between Coffee Street and Washington Street, you can find a sculpted rooster embedded into a building. Take a stroll between the blocks and try to find it. There is a great story behind that feathery little fowl. According to Beverly Merritt, her grandfather Sol (short for Solomon) Knigoff was a Jewish man who grew up in late nineteenth-century Russia during the reign of the last tsars. Looking to escape the hardships of Russian life, Sol managed to flee Russia in 1903. Russian Jews faced widespread anti-Semitic persecution in the last few decades of the nineteenth century in the form of ethnic riots called pogroms. As the pogroms became bloodier in the first years of the twentieth century, Sol fled for his safety and a better life. His choice to leave was fortunate and the timing was even better. Within a decade, the Bolshevik Revolution took place and ushered in the new era of Communism, with tens of thousands of civilian Jews killed in more pogroms.

Where was his destination? America. More immigrants came to America in the first decade of the century than any other period in recorded history. About one and a quarter million others from all over the world were headed in the same direction as Sol. In the days before transatlantic passenger jets, everyone had to cross the "big pond" on ocean liners. Sometime between leaving his hometown of Minsk and leaving Europe, Sol met a stone carver and the two formed a friendship. The common bond of leaving their homelands to start a new life of opportunity in America likely played a large part in their camaraderie.

After 1892, almost all immigrants arrived in New York City through Ellis Island, just like Sol. Before parting ways, Sol and his sculptor friend said their goodbyes. The stone carver made a promise that after he established his business he would sculpt a rooster and send it to Sol as a token of the friendship they made on their shared trip to America. The reason for the choice of a rooster is not documented. However, its symbolic meaning in Russian culture can refer to "fulfillment of wishes." European churches (especially in Amsterdam) are known to have roosters surmounting their buildings instead of crosses. The symbolism refers to the Apostle Peter's denial of knowing Christ after He was taken from Gethsemane to ultimately be crucified and die to pay for the sins of mankind. The rooster's crow was the signal to Peter that Christ's prophecy of his denial had come to pass. The rooster, therefore, was used as a symbolic reminder on churches for believers not to deny their Savior.

Sol first went to Augusta, Georgia, to stay with his sponsor and made his way to Greenville a year later to put his roots down. The Greenville City Directory indicates that Sol initially lived in the Commercial Hotel. He quickly went into business for himself and opened up the Manhattan Pawn Shop, determined to make enough money to bring his brothers and sister to America. He reorganized the business under his own name, Uncle Sol's Pawn Shop, at 111 South Main Street by 1912. The stone carver kept his promise and sent Sol the sculpted rooster, which he installed into the exterior wall at the top of his pawnshop. The building later burned down and the only thing Sol was able to salvage from the ruins was the sculpture. When he reopened his pawnshop in the present building, the rooster was proudly installed at the top of the façade. Sol eventually changed businesses and opened up Kingoff Jewelers in 1919. He also went on to help organize the Congregation Beth Israel and the Temple of Israel in Greenville.

Since the nationality of Sol's friend is not known, it is impossible to know for sure the sculptor's intent for the symbolism of the carved rooster. Nonetheless, we can be confident that what the gift meant to Sol was a profound memory of his friend and their momentous journey together.

Tour 3

North Main Street
Coffee Street to Elford Street

The portion of North Main Street on this tour particularly reveals highlights of Greenville's history from the first half of the twentieth century. It wasn't until the turn of the century that the land began to develop in earnest from a residential neighborhood to an extension of the commercial district. Consequently, this tour highlights some of the enduring features that reflect this era and continue to be a part of the Greenville experience today.

1. Cauble Building

The northeast corner of North Main and Coffee Streets is the location of one of the early saloons in Greenville's days as a

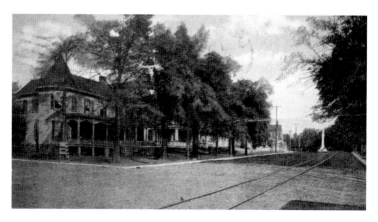

In the late 1800s, the block of North Main Street between North Street and College Street on the west side was filled with grand wooden homes. *Courtesy of the Greenville County Library System.*

Tour 3: North Main Street—Coffee Street to Elford Street. *Courtesy of the City of Greenville.*

small village. The Last Chance Saloon stood on the corner of a well-traveled intersection that turned the corner from the "wagon road" leading to the North Carolina mountains in one direction and the other leg leading down North Main Street to the heart of the village at Court Square.

At the close of the nineteenth century, the property was sold by Peter Cauble's daughter-in-law, Carrie Vickers Cauble, to B.A. Morgan to become the home of the Bank of Commerce in 1905. It was the most northerly location for a bank on Main Street up to that time. The site was transformed from a place where people went to squander their money on booze to a place where locals could save and invest in their futures. The impressive new two-story brick building extends down Main Street and Coffee Street with an angled corner main entrance facing the intersection set off with two Corinthian columns supporting an arch. According to Henry McKoy, the entrance to the Cauble Building, like most early twentieth-century buildings, originally went several steps off of the street to keep the mud from easily entering in. Greenville was particularly notorious for having muddy streets that were nearly impassable after heavy rains. A third story goes underground with access by stairs on the Coffee Street side.

The Bank of Commerce only lasted twenty-one years before abruptly closing. One of the other early tenants of the building, the Unique Theater, brought back the location's theme of entertainment and leisure. However, this time it was not with the

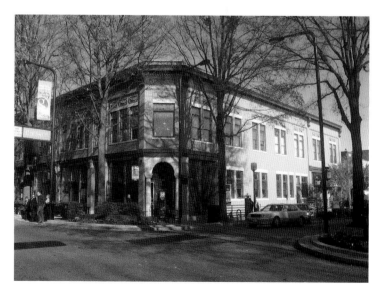

The Cauble Building was built on the northeast corner of North Main and East Coffee Streets in 1905.

favorite male pastime of the nineteenth century (saloons), but with the rage of the twentieth century—movies. The Unique was the first of many theaters to come to Greenville in the early twentieth century. The Rialto Theater would later be located directly across the street on the southeast corner of North Main and Coffee Streets.

In the late 1950s, America's fascination with modern art and architecture came to Greenville. The charming brick character of turn-of-the-century buildings was considered passé and, consequently, the face of Greenville changed dramatically. The Cauble family heirs continued to own this corner building and invested $30,000 to "modernize" it by covering the exterior in aqua-colored aluminum sheeting. The property remained in the Cauble family for 145 years and the building for 81 years before it was sold in 1986. The Cauble Building's historic role in the city's development spans two significant periods. When it was built in 1905, it helped begin the commercial takeover of the east side of Main Street with large and architecturally significant buildings. In the 1980s, the removal of the "modern" façade and subsequent restoration encouraged a chain of similar renovations in the downtown area—infusing an element of charm and history that can never be replicated with new construction. Greenville's mix of old and (tasteful) new architecture is one of its greatest assets in the twenty-first century.

2. Meyers-Arnold Building

For nearly half of Greenville's history, the western side of Main Street to the north of Coffee Street was open field and pasture that became known as Sandy Flat. Residential homes eventually were built before commercial expansion inevitably took over the area. By the last decade of the nineteenth century, the predecessor to Meyers-Arnold Department Store had already established a presence in a small storefront on the present site. According to the *Greenville Piedmont*, the origins of the company started with James H. Morgan as a general merchandise enterprise. Morgan sold out to G. Heyward Mahon and J. Thomas Arnold by 1901 and the name was changed to Mahon & Arnold. The company touted itself as "The College Girls' Store," catering to the needs of the girls at the Greenville Women's College and Chicora College. Arnold later ran the business on his own before selling a stake in the merchandise store to Manos Meyers and his four brothers in 1911—thence becoming known as the Meyers-Arnold Company. Some of their original specialty items included Warner Brothers Corsets, La Grecque Corsets, Merode Underwear and Onyx

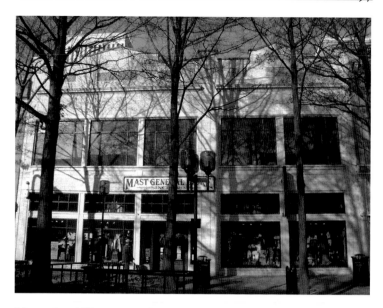

Meyers-Arnold Department Store occupied this building for about half a century. Today Mast General Store is one of downtown Greenville's most successful retail businesses and is poised to remain, as its predecessor, a local favorite for many years to come.

Hosiery. By the mid-1900s, the Greenville-based department store was one of the oldest and most popular in the city, though rivals like Ivey's were moving in throughout Main Street.

The family-owned Meyers-Arnold store was a Greenville fixture for most of the twentieth century, with eight stores in the Carolinas and Georgia, until it was bought out by Upton's Department Store in 1987. Just as Meyers-Arnold closed its eighty-four-year-old business, downtown Greenville's revitalization was coming to fruition after many years of planning by city officials. The Hyatt Hotel had recently opened and the 1905 Cauble Building across the street on the corner of Coffee and Main Streets had just received an impressive renovation to restore it to its original look.

Greenville city officials rejoiced when Mast General Store answered the call to bring a thriving regional retail store into the heart of downtown Greenville in the former Meyers-Arnold Building. Mast's down-home charm, quality products and personalized service made it a perfect fit to anchor the retail section of North Main Street. Henry Taylor opened the original store in the secluded mountain valley of Valle Crucis, North Carolina, in 1883. Eventually the business was taken over by W.W. Mast and thrived under the mindset and slogan, "If you can't get it here, you don't need it." Since its beginning, Mast

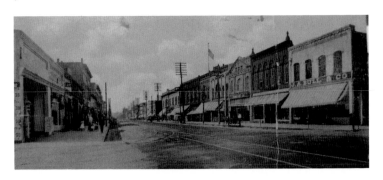

On the right side of this turn-of-the-century photo is the where Meyers-Arnold (and later Mast General) would occupy. *Courtesy of the Greenville County Library System.*

has specialized in "traditional mercantile goods, comfortable clothing, rugged footwear and quality outdoor gear for all mountain seasons." The same is true of its Greenville location, which opened in March 2003. Besides the array of unique items for men and women, kids of all ages especially enjoy the mix of over five hundred old-fashioned and hard-to-find candies.

3. Findlay Building

Until the late 1800s, this city block between what is now North Street and Beattie was composed of large residential and boarding homes. According to Henry McKoy, the earliest known home on the northeast corner of North Main and East North Streets was P.A. McDavid's two-story wooden Magnolia House. What was then outside of "downtown" Greenville is now the heart of the city's thriving north end of downtown. As Greenville's business district crept north from Court Square, the first commercial building to appear on this corner was known as the Findlay Building. Magnolia House was moved a block and a half east to make way for the Findlay in 1912. The building was named after its original owner, James F. Findlay. Farr & Findlay grocers were the first occupants of the building in a storefront facing North Main Street (approximately where Bertolo's Pizza now stands). Terminating the two-story portion of the Findlay Building facing Main Street was a three-story section at the far left originally occupied by King & Browning Furniture Co. Physicians and dentists filled in the rest of the offices in the ensuing years. In 1935, the building caught fire in the first-floor Greenville Pharmacy. Henry McKoy, whose construction business office was located on the second floor, was contracted to restore the building to its original condition.

The former Ivey's Department Store on North Main Street is a renovated brick building that dates back to 1912.

When Charlotte businessman J.B. Ivey opened his first department store in Greenville, it was located across the street on the west side of this same block in the former five-story Craig-Rush Building. In 1950, Ivey's Department Store sought to expand and moved its store to the old Findlay Building. New York architect E. Paul Behles worked with Daniel Construction Company to remodel the Findlay Building in a modified Colonial style. Two stories were added to the existing structure, with large central pediments on each side of the building. An eighty-seat auditorium was a featured item on the second floor that allowed public and commercial groups to host downtown meetings. The brick walls were completely covered over with stucco and glass storefronts. The main entrance remained in the same place, though Daniel added an imposing two-story cornice with classical engaged columns topped with Corinthian capitals. Ivey's closed its downtown store in 1972 when it remodeled and expanded its McAlister Square mall store. The regional chain sold off its stores in 1990. A later remodel of the former downtown Ivey's converted the upper floors into condominiums with balconies that overlook Main Street. Today an observant visitor going through the central Main Street entrance will notice the "Ivey's" logo embedded in the entrance floor.

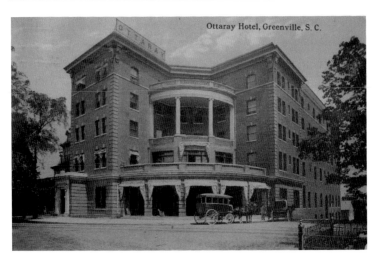

The Ottaray Hotel once overlooked Main Street where the Hyatt Hotel now stands. Built in 1909 with a distinctive semicircular series of porches, it is one of the most beautiful structures in Greenville's history. *Courtesy of the Greenville County Library System.*

4. Ottaray Hotel

On the day of its opening celebration on June 16, 1909, the *Greenville News* described the eighty-three-room Ottaray Hotel as "magnificent in its architectural splendor and beautiful in its furnishings that are at once artistic and finished, the handsome new Hotel—a hostelry of which a city thrice the size of Greenville might well be justly proud—will be thrown open to the public at six o'clock." Nearly a century after Greenville's first great hotel (the Mansion House) was built, the city could now boast anew with its elegant and architecturally unique hotel. The Ottaray was designed by George Lafaye and built at the highest point in the city on the northeast corner of North Main and Oak Streets. The cost of construction totaled nearly $80,000.

Since the city's inception, downtown commercial development had always centered in the area around Court Square and slowly branched out from there. The new belle of the city was placed on the far north end of Main Street in an area still populated mainly with grand residential homes. The most impressive feature was the stately semicircular balcony supported by four two-story columns. It connected the two five-story brick "wings" and provided what would be the most coveted, socially relaxing place in town. Guests and residents alike eased into one of the many wooden rocking chairs to chat, gossip, watch the attraction of automobiles going down the street and get a clear bird's-eye

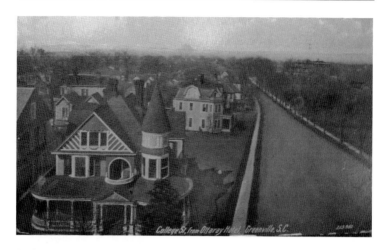

A view enjoyed by guests of the Ottaray Hotel on College Street looking west. Many Victorian mansions line the street leading to the Greenville Women's College in the distance. *Courtesy of the Greenville County Library System.*

view looking south of the entire Main Street. To the west could be seen the beautiful campus of Greenville Women's College a few blocks away.

Within just a few years, word spread throughout the nation about the charms and quality of the Ottaray. A sixty-room addition was complete by 1922 under the new leadership of J.L. Alexander and his son, J. Mason. Business prospered for eleven years until the Ottaray fell under the shadow (figuratively, not quite literally in spite of the twelve-story height) of the Poinsett Hotel on Court Square. Within five years, J. Mason Alexander would leave the Ottaray to manage the Poinsett into its greatest days. Meanwhile, the Ottaray came under the management of J. Mason's brother, L.V. Alexander. The majestic old hotel could not remain competitive into the second half of the century. In 1962, one of Greenville's most beautiful historic buildings was torn down to make way for a new "modern" motel. The Downtowner Motor Inn was built by Daniel Construction Co. in its place for a total cost of nearly $1 million. The new building was praised by city officials as a symbol of the city's progress and growth, but the quickly dated motel would not come through as a long-term downtown economic (and architectural) asset.

After nearly $2 million were spent on projects to beautify Main Street in early 1979, the city was eager to find a new anchor to draw people back into downtown. The Downtowner Motor Inn was torn down to make way for a new $34 million Hyatt Regency hotel complex that included 330 rooms, a five-story office building, restaurant, convention center and an

impressive seventy-foot atrium lobby. Oak Street was eliminated and other streets reconfigured around the massive construction site. At its opening in 1982, the Hyatt Hotel was the first major commercial project to spark the revitalization of a downtown that had languished for decades. In recent decades, the Peace Center, Falls Park, Riverplace and the West End Field have secured Greenville's goals for making downtown a thriving destination for locals and tourists alike.

A whimsical and fun art project/activity created in the 1990s begins in front of the Hyatt Regency. A student project at Christ Church Episcopal School inspired Jimmy Ryan to come up with the idea to place mice in Greenville as a scavenger hunt for children to be involved in the enjoyment of the downtown atmosphere. The idea got past the classroom walls and was made a reality, to the enjoyment of kids of all ages. A bronzed sculpture of the classic children's book, *Goodnight Moon* by Margaret W. Brown, starts the fun on the ledge of the Hyatt's courtyard fountain. The story is about a young bunny rabbit that is compelled to tell every person and

One of the nine tiny bronze *Mice on Main* waits for pedestrians to discover it along Main Street. The activity begins at the courtyard fountain of the Hyatt Regency and has become a favorite family friendly activity in downtown Greenville.

thing that he sees or thinks of "goodnight" before he goes to bed. On each page of the book is a recurring little white mouse that children love to find each time the page is turned. Instructions are given at the sculpture to wander down the sidewalks and find tiny bronze mice scattered at various locations along both sides of Main Street. Keep a sharp eye out because they are found high and low!

For those who would like some helpful hints on their adventure, a list can be obtained from the Hyatt's front desk, the CVB's information center in city hall or the city's website at www.greatergreenville.com/visitors/mice.asp.

5. Daniel Building

The Daniel Building is a monument to the man whose name it bears, Charles Ezra Daniel. While growing up in Anderson, South Carolina, Charles was employed by the Townsend Lumber Co. Through speed, efficiency and hard work, he contributed significantly to the company's growth into a million-dollar enterprise building textile mill housing. Charles began his own construction business in 1934 and quickly became successful through government contracts offered in the New Deal by the Public Works Administration.

The Daniel Building was the tallest skyscraper in the state when it was built in 1965.

Soon Daniel saw the prospects afforded by the Greenville community and relocated his business here in 1942. Contracts came in from all around the South as Daniel Construction became renowned for its ability to deliver quality buildings that were built quickly and less expensively than its competitors. Over the ensuing decades, Daniel Construction became the primary builder of new large textile mills—especially those of J.P. Stevens & Co. and Deering-Milliken & Co. (two of the largest textile firms in the nation). Charles Daniel also had an uncanny ability to lure prominent Northern companies to build expansions in the South.

Daniel served briefly in the U.S. Senate in 1954 when appointed to finish the term of the deceased Senator Burnet Maybank. Two years later, Daniel was recognized by *Fortune* magazine as one of the nation's top industrial leaders. Indeed, Daniel International Construction at one time was the largest construction company in the world, securing large projects like paper mill and nuclear power construction. Before his death by cancer in 1964, Daniel's company was responsible for over $2 billion in construction projects, the creation of 175,000 new jobs and 250 manufacturing plants in the state. The same year that Daniel died, a twenty-five-story skyscraper designed by the Atlanta architectural firm of Stevens & Wilkinson was being built as his company's new corporate headquarters. It was the largest building in the state and served as a symbol of the prestige and economic prosperity that Daniel's vision brought to Greenville and South Carolina.

Buildings erected by Daniel Construction are found all over Greenville, including Donaldson Air Force Base, additions to First Baptist Church, Bob Jones University campus, the Hyatt Regency and the Greenville-Spartanburg airport. Daniel merged with Fluor Corporation in 1977 to become Fluor-Daniel Corp. The Daniel Building had a multimillion-dollar renovation in recent years and is now known as the Landmark Building.

6. Springwood Cemetery

Springwood Cemetery has the distinction of being South Carolina's oldest municipal cemetery and one of Greenville's most historic sites. Its origin goes back to the earliest settlement of the city, when land was granted after the Revolutionary War to John Timmons in 1784. At the time, the property was far outside of the tiny development that had grown up near the falls of the Reedy River. Eventually the land was purchased by Chancellor Waddy Thompson, an early village leader who was elected to the state House of Representatives. He built a three-story mansion at the head of what would become Main Street (later the site of the Carolina Theater). Thompson's mother-in-law, Elizabeth Blackburn Williams, came to live with him and spent her time enjoying the extensive gardens surrounding the house.

When Mrs. Williams died on July 15, 1815, she was buried on the Thompson property amidst the gardens where she loved

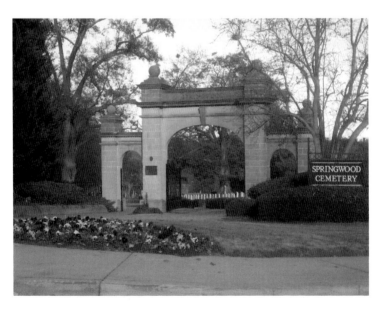

Springwood Cemetery is Greenville's oldest cemetery (1812).

to sit and relax. Her grave was the first of what would later become Springwood Cemetery. According to Lucile P. Ward, two years later Chancellor Thompson sold part of his land to Francis McLeod who opened up the land for public burial in 1829. After McLeod deeded part of the property to the city in 1833, larger tracts of surrounding land were added through the years to bring the cemetery's current dimension to thirty acres.

Cemeteries provide a unique historical perspective and Springwood spans a time period that is unsurpassed by any in Greenville. While only names on gravestones remain, the stories behind the lives and roles each have played in the city's development would fill innumerable volumes. Regardless of wealth, race, occupation, faith, age or accomplishments, the people remembered here deserve the respect and honor from all who visit.

With a history as long as Springwood's, only a few people and facets within its gates can be recounted here. First of all, the military men and women buried here represent nearly every major conflict in our nation's history. Remains of soldiers from the Revolutionary War, Mexican War, Civil War, Spanish-American War, World War I, World War II, Korean War and Vietnam War all rest in peace here.

Thousands of occupations and walks of life are accounted for in Springwood. Martin Ansel served as governor of South Carolina from 1907 to 1911. Dr. Burwell Chick ran the popular Chick Springs resort and hotel in Taylors for five years before being buried here. Dr. William Mauldin, namesake of the town bordering Greenville, is buried in Springwood. Nearly all of Furman University's early presidents are buried here, including James Clement Furman, Charles Manly, Edwin Poteat, William McGlothlain, Bennette Geer and John Plyler. Mary Camilla Judson began teaching at the Greenville Female College in 1857 and went on to serve as its first female principal from 1878 to 1903. After she died and was buried in Springwood, students from the nearby college regularly brought chains made of daisies to her grave. The graves of textile mill owners Otis P. Mills and Fred W. Symmes are found here. U.S. Fourth Circuit Judge Clement F. Haynsworth Jr. and former U.S. Senator and Greenville businessman Charles E. Daniel are two other notable citizens buried in the cemetery. Currently there are nearly 8,000 marked graves, with an estimated 2,600 more that are unmarked.

Just outside the main entrance to Springwood is a plot dedicated to Confederate soldiers. Towering over the spot is a tall monument with a pillar surmounted by a Confederate officer. It was originally placed in the middle of North Main Street (in front of where the Ottaray Hotel would later be built)

and dedicated in 1892 by the Ladies' Memorial Association in tribute to more than 2,500 soldiers from Greenville County who had fought in the War Between the States. The sculptor's model for the Confederate figure is said to be James Blackman Ligon, who would later become the city's chief of police. He was chosen for his bravery in war, having survived twenty-six battles and three war wounds. Greenville's increasing automobile traffic caused a removal of the monument and its placement next to Springwood's main entrance in 1924.

Springwood Cemetery is likely named for the spring that flowed through the woods on the property, fed two ponds and emptied into nearby creeks. Today the location of this spring is remembered by an old stone arch now on the property of the Kilgore-Lewis House. Inscribed across the keystone is the phrase, "Thank God for Water."

Tour 4

Architecture in Greenville

An integral part of any city's history is found in its architecture. Tastes and styles are reflected in the structures built on its streets. Our contemporary understanding of these buildings is often limited by the change in context provided by their original cultures, owners and environments. For instance, when the Beattie House was built around 1834 it was located in the woods at a remote distance from the village. Today we appreciate the building with later modifications within a neighborhood at its third location. Nonetheless, a city is always richer when its historic structures endure the generations and are assimilated into the fabric of society.

The following tour is meant to bring attention to representative examples of architecture from Greenville's earliest days as a village through the thriving city of the twentieth century. Under the theme of architecture, the tour is written for the average visitor rather than the expert. To really do justice to the subject, a dedicated volume would have to be written. Instead, visitors can be introduced to some important structures that may get missed on a casual tour of Greenville. Besides the architectural significance, the history of the buildings and their role in Greenville's culture is also worth commemorating. One building on the tour no longer exists, but is important to be remembered as one of the city's great architectural treasures.

Beyond the buildings listed on this tour, downtown Greenville is surrounded by historic districts on all sides that offer a plethora of architectural styles reflecting Greenville's development and growth. To the north, the Earle Street Historic District has grand early twentieth-century homes in the Tudor, Dutch Colonial and Georgian Revival styles. To the west, the Hampton-Pinckney Historic District has excellent examples from the late nineteenth

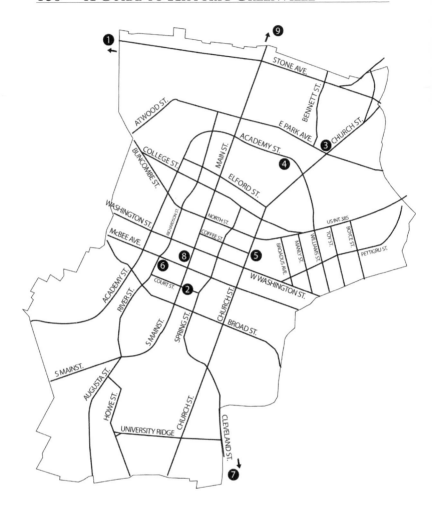

Tour 4: Architecture in Greenville.

and early twentieth centuries, including Queen Anne Victorians, Arts and Crafts, Greek-Italianate, Italianate and Gothic-Revival styles. Homes to the east of the city in the Pettigru Historic District and to the southeast off Augusta Road represent many styles and are well worth a visit.

1. Whitehall

The early owner of this historic home was South Carolina Governor Henry Middleton. As the son of Arthur Middleton, signer of the Declaration of Independence, Henry grew up in a privileged Charleston environment, being tutored at his

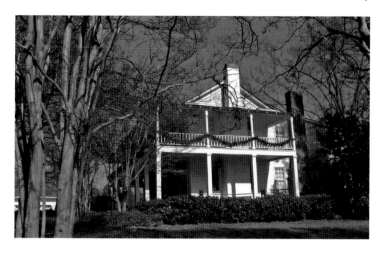

Whitehall was the summer home of South Carolina Governor Henry Middleton and is one of the oldest extant structures in the city.

grandfather's large plantation house, Middleton Place. After serving terms in the South Carolina Legislature and Senate, Henry was elected governor in 1810. A year after he left office Henry, like many other Charlestonians, looked to Greenville as a summer retreat and bought land from Lemuel Alston in 1813.

Whitehall's design follows elements popular in many of the houses found in Middleton's hometown. The dominant features imported from Charleston were the large verandas that wrap around the front and left sides on both stories. Square pillars support the first-tier overhang, while turned posts support the second. A balustrade (not original) runs the course of the entire second-floor veranda. Charlestonians love these cool and shady breezeways to use for socializing and relaxation.

Henry Middleton went on to serve in the U.S. House of Representatives for South Carolina from 1815 to 1819. A year later, Whitehall was purchased by George Washington Earle, who gave it to his daughter. Eugenia Earle married Charles B. Stone and the house has remained in the family by inheritance ever since. Of particular historical interest during those years was the home's use as a nurse's residence when Camp Wetherill was stationed on the adjacent land during the Spanish-American War.

Though alterations have been made, the house is historically important to Greenville for being one of, if not the oldest existing home in the city (The Poplars on Buist Street and the Earle Town House on James Street may be earlier). It certainly reflects the period and charm of Charlestonian architecture perhaps more than any other. Furthermore, unlike other early nineteenth-century homes in the area like the Beattie House

(circa 1834) and Kilgore-Lewis House (circa 1838), Whitehall remains in its original location.

310 West Earle Street
Greenville, SC 29601

Traveling north on North Main Street, turn left on Earle Street and drive four blocks down. The house is on the right-hand side with a historical marker in front of it.

2. Greenville County Courthouse Designed by Robert Mills

Perhaps the most attractive and historically important building in Greenville history was the county courthouse designed by Charleston architect Robert Mills (he would later design the Washington Monument in Washington, D.C.). As commissioner of the South Carolina Board of Public Works, Robert Mills surveyed the condition of buildings in the state and recommended a new courthouse and jail for Greenville. A contract was signed in 1821 and the building was underway the

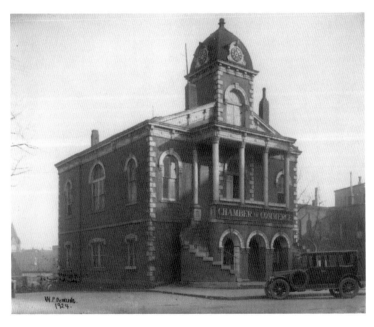

The Greenville County Courthouse designed by Robert Mills in 1822 once stood in the heart of downtown Greenville at Court Square. It lasted one hundred years until it was torn down to make way for the new ten-story Chamber of Commerce Building.

next year. Greenville's courthouse was similar to other designs Mills was churning out in those years. However, he was sure to make each of his buildings distinct. The body of the two-story brick building was nearly a square cube in format, with stone quoins running the full height of each corner. The three side windows on the first floor were rectangular with hooded moldings, while the side windows on the second floor contained decorative arches with keystones at their apex. Originally the roof was a simple gabled style, but in the late nineteenth century was modified with Jacob Cagle's addition of a tower cupola with a decorative clock on each side.

The façade comprised the most appealing features and gave Greenville's Court Square a Charlestonian flair. Two-thirds of the second floor were dominated by a projecting loggia supported by four columns with Corinthian capitals across the front and two more engaged columns on the main structure. Sweeping staircases led up to each side of the second-floor loggia, while three arched doorways clustered between the stairs on the street level.

Besides acting as a place to settle civic and government matters of law, the courthouse was also used for a number of other matters of everyday life in nineteenth-century Greenville. Prior to the Civil War, the loggia's balcony was used to auction slaves for area planters and businessmen. Before permanent churches were built in the city, both traveling and local ministers like William Bullein Johnson preached at the courthouse. Politicians such as John C. Calhoun would speak from the balcony to inform and persuade locals about issues such as nullification.

When the next county courthouse was built across the street in 1855–56, Mills's courthouse was converted into offices for county records and also the chamber of commerce. At the end of the century the building even had rooms for use by the YMCA. The building lasted for just over a hundred years, but complications involving its renovation, outdated style and electrification prompted a call for demolition in 1924. With its destruction Greenville lost an important early American piece of architecture.

135 South Main Street
Greenville, SC 29601

3. Beattie House

Though the Beattie House has received a number of alterations over the years, it remains a stunning example of nineteenth-century architecture and one of Greenville's oldest extant

homes. Fountain Fox Beattie paid $400 to Edward Croft for the three acres of property in 1834. At that time the home's original location was on what would become the northwest corner of East North and Church Streets. The two-story central portion of the home is the only original part of the structure, though the Italianate style that characterizes its look now gives no indication of the former Georgian style it had upon completion. Fireplaces with exterior chimneys are found on the right and left sides of the building, providing the only form of heat to the home for nearly a century. A central second-floor double window is flanked by a pair of single windows on either side. These single windows are mirrored on the first floor, while double doors with a dentiled entablature provide a welcoming entrance. The original brick building was later covered in clapboard siding and one-story wings were added on either side of the home. Today the house includes a drawing room, large meeting room, coat room, powder room, dining room, office, kitchen and an enclosed back porch.

Sometime during the late nineteenth century, the home was expanded and converted into the then-popular Italianate style. The front porch extends about ten feet out and is supported by six pairs of square columns with one additional column completing the turn around the right and left corners. Three large arches span the front of the porch, while two smaller arches connect them in a picturesque manner to either side of

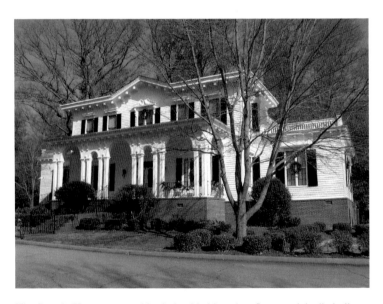

The Beattie House now resides in its third location. It was originally built circa 1834 on what would become the northwest corner of East North and Church Streets.

the stairway entrance. One large arch is also found on each end of the porch. The cornice is decorated with dentil molding with pairs of consoles extending down from the cornice above the columns.

The young F.F. Beattie had the home built for his new bride, Emily Edgeworth Hamlin of Charleston. Hamlin Beattie, founder of the first bank in Greenville at the close of the Civil War, lived here for a time. The house stayed in the family for 104 years until its last descendant, Mary Caroline Mays Beattie, died in 1938. The home was bought by the city in 1946 for $72,500 and was moved north about three hundred feet to 1 Beattie Place, with a team of mules pulling the home on a series of logs. In its new (second) location, the Greenville Women's Club took up residency and has remained ever since. Some of the functions of the club include a monthly literary hour to review current bestsellers, afternoon teas, private luncheons and other social events.

U.S. Shelter became interested in the prime downtown real estate of the Beattie property and wanted to build a pair of skyscrapers there. Instead of being torn down, the home was moved yet again in June 1983. The half-mile journey took fourteen hours to transport the two-hundred-ton home. It was moved by the same company that had moved it the first time, thirty-seven years earlier. The Greenville Women's Club is responsible for its restoration at the time of its move. The Beattie House was accepted to the National Register of Historic Places in 1974.

8 Bennett Street
Greenville, SC 29601

4. Kilgore-Lewis House

Only a handful of homes are left in Greenville that predate the mid-nineteenth century, and the Kilgore-Lewis is one of them. Wooden residential buildings from this period are relatively rare because so many have burned down over the years from kitchen fires, lightning, heating stoves, citywide fires and more. For Greenville, the Kilgore-Lewis home is significant for the period it represents in addition to its own architectural identity.

Josiah Kilgore bought the land from George Boyle on May 18, 1838, for $1,200 on Buncombe Street, adjacent to what would become the campus of the Greenville Male and Female Academies (now Heritage Green). The two-story home built by Boyle a few years earlier was the location of Kilgore's daughter, Mary Keziah's wedding to John Stokes. After the vows were said,

Kilgore gave a gift any bride (and husband) would be astounded by—the new home was theirs to live in. The home has three large rooms upstairs and another three large rooms on the first floor. The wide front façade presents a grand Palladian profile with two pairs of massive square columns soaring two stories to support a projecting gabled roof. The front pediment is accented by an attractive oculus window. Its original construction consists mostly of heart pine boards that are fastened together with pegs. The rear elevation has a smaller two-story projection coming off the center of the front section of the house. Two-story chimneys are found on the ends of each of the side and rear wings. The home is remarkably similar, though less grand, to John C. Calhoun's home in Pendleton, South Carolina.

Later in the nineteenth century, the house passed by inheritance to Mrs. Lillian (Stokes) Lewis and remained in the Lewis family until 1974, when the home was donated to its neighbor, Buncombe Street United Methodist Church. Just as the Greenville Women's Club had formed and moved one of Greenville's other oldest homes (Beattie House) to a new location before moving in (1949), such were the circumstances surrounding the move of the Kilgore-Lewis home twenty-five years later in 1974. The Greenville Council of Garden Clubs took over the ownership and spearheaded the effort to save the home from demolition, move it to a new (current) location and restore many of the original details.

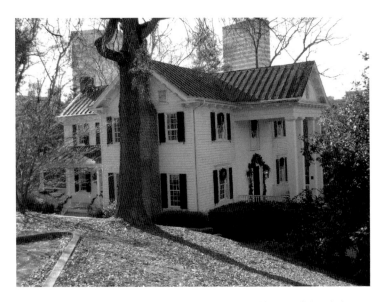

The Kilgore-Lewis House was built in the 1830s and is one of the city's oldest extant homes. Its original location was on Buncombe Street and was moved to the Academy Street site in the 1970s.

The home's new Academy Street location adjoins the boundary of Springwood Cemetery—the former land and garden area of Chancellor Waddy Thompson (it is now a nationally certified Backyard Wildlife Habitat). There is a spring in the back of the property that, according to Henry McKoy, was likely the source of the name for Springwood when the spring was located in the woods and used as a water source for Thompson's home diagonally across the cemetery.

560 North Academy Street
Greenville, SC 29601
www.kilgore-lewis.org

5. Christ Church Episcopal

Christ Church Episcopal Church is the oldest extant church and earliest established congregation in Greenville. It began when Reverend Rodolphus Dickerson arrived in 1820 to establish an Episcopal presence in the village through St. James Mission. Dickerson was able to attract a few natives but soon discovered that the population (and congregation) would swell in the summers when Charlestonians would make their retreat to Greenville. Services were held in the log courthouse in the

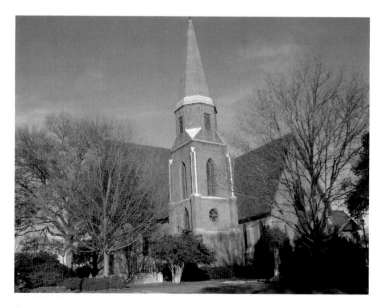

Christ Church Episcopal is the oldest extant church in downtown Greenville (1854). This beautiful building has stained glass by Mayer Studios in Munich and also Tiffany & Co. in New York.

center of Court Square. Five years later, Vardry McBee (even though he was still living in North Carolina) provided four acres of land on the east side of the village for the St. James congregation to build a church. This first structure was built on the same property of the current church but was located just to the south. The first small brick church measured fifty-five by thirty by eighteen feet and took many years to fully complete. A balcony for African Americans and a belfry were added in the 1830s with funds obtained through the common practice of renting church pews. St. James Mission was admitted into the Diocese in 1828 and was renamed Christ Church.

Greenville's growth and prosperity began to take off in the next decades, and so did the size of Christ Church congregation. Plans began in 1845 for the erection of a larger church to meet their needs. Initially plans were submitted by Vestryman Joel Poinsett but were later rejected for the high cost. Eventually Reverend John D. McCollough's Gothic cruciform designs (similar to designs by popular Neo-Gothic architect Richard Upjohn) were accepted and a cornerstone was laid in 1852. Bricks from the former church were used as the foundation of the new one. Two years later the new $15,000 brick building was dedicated but consisted only of the nave and a belfry. The nave is thirty-nine feet wide with short brick buttresses and a sixty-five-foot-high steep gabled roof that slopes halfway down the building's height. The sides of the nave are pierced with narrow lancet arch windows with stained glass. One of the stained-glass windows was made by Tiffany & Co. in New York City (other Tiffany windows in Greenville may also be found in Bob Jones University's boardroom and at the Gassaway Mansion). The altar wall of the nave originally had three tall narrow lancet arch stained-glass windows by Wills of New York. Funds raised by ladies in the Christ Church Guild were put toward the installation in 1914 of a massive stained-glass window depicting Christ's *Ascension* and *The Last Supper* created by Mayer Studios of Munich, Germany.

The impressive belfry rises 130 feet into the air and is set asymmetrically off to the side—a technique derived from English country models and used by Richard Upjohn in New England. The simple square-shaped base has projecting corner piers, all of which provide the foundational means to support the weight of the tower. The second tier has a decorative oculus stained-glass window with trefoil design on the south side with short lancet arch windows on the east and west ends. The third part of the tower is the tallest brick section, with soaring lancet arch windows on each side. The angled transition with inverted triangular broaches narrows to the next level, creating an octagonal shape for the remainder of the structure. Four

rectangular windows provide variety for the fourth level before a brick (not tile or copper) octagonal steeple soars to its pointed apex. The transepts were added in later years (1880 and 1958) and complete the original design plan.

Christ Church Episcopal is the only downtown church to have a cemetery associated with it on the grounds (as directed by Vardry McBee). The first grave was established in 1835 for parishioner Sarah Crittenden. It is the final resting place for many of Greenville's leaders, including Vardry McBee, Governor Benjamin Perry, Mayor T.C. Gower, H.C. Markley and Hamlin Beattie.

10 North Church Street
Greenville, SC 29601
www.ccgsc.org

6. First Baptist Church

Though the Episcopals were the first Christian church to establish a congregation in Greenville, the Baptists soon followed. Vardry McBee donated a 120-square-foot lot on the corner of what is now Irvine and East McBee Avenue in 1825, even though local Baptists at the time mostly traveled out to Brushy Creek Baptist seven miles away. Baptist preacher William Bullein Johnson came to Greenville to teach at Greenville's new academies for boys and girls and instigated public subscription for the building of a church in the city. In 1826, a 52- by 32-foot brick Baptist meetinghouse was built on the lot donated by McBee. Soon a ten-member (one man, nine women) congregation officially organized as Greenville Baptist Church in 1831. From its earliest days, the congregation consisted of both white and black members. In 1847, it certified Gabriel Poole as a preacher. Poole was later granted permission to allow Reverend James Rosemond to travel with him to learn to be a preacher. They remained great friends throughout their lives, and promised each other that the remaining friend would preach the funeral of the first to go. When Gabriel died in the early 1900s, James did indeed preach his funeral. After the Civil War, when Poole and others gained their freedom, Poole and the new African American congregation he formed met in the basement of the Baptist church until they built their own, Springfield Baptist Church, on McBee Avenue in 1871.

In 1849, money had been raised to erect a steeple on the old Baptist meetinghouse. After consideration, it was believed that the money would be better spent going toward a new building with a steeple. A goal was set but a new building was still far off.

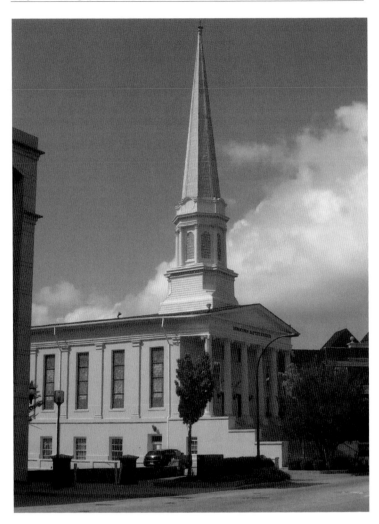

First (now Downtown) Baptist Church is the second oldest extant church building in the city. It was built in 1858 in the classical Greek Revival style.

A significant revival and the coming of Furman University in 1851 caused plans to move forward in earnest to build a larger church. Since Furman was a Baptist institution, naturally its members attended Greenville Baptist Church. Various faculty members would become leaders in the church, such as Dr. James C. Furman's election to the pastorate in 1852. Likewise, the establishment of the Greenville Baptist Female College in 1854 enlarged the congregation even more. Under the leadership of Pastor Furman, the new church was finally realized in 1858. The very next year, the old Baptist meetinghouse was taken over for use by the Southern Baptist Theological Seminary from 1859 to 1877.

The new Baptist church was built on a large lot on the corner of West McBee Avenue and River Street. Philadelphia architect Samuel Sloan designed the building, which would become the tallest structure in the city for many years to come. The austere Greek Revival architectural style was chosen and made the church the first major construction in the city of that type. Six massive two-story fluted Ionic columns supporting a simple entablature and pediment set the tone of the classical structure. A grand, steep set of stairs (later widened) led up to the second-floor entrance, giving an impression of the stately federal buildings in Washington, D.C., that were built in this same era. What sets the building apart as a distinctly religious building is the soaring central spire.

Across the sides of the nave are six bays separated by pilasters, with stained glass (added later) decorating each window. The original main entrance consisted of two centrally placed one-story doors. A later renovation has converted it to three doorways with windows placed directly above.

During the late nineteenth century, the church continued to grow and hosted many sessions of the Southern Baptist Convention. In 1890, Greenville Baptist Church sought and obtained state approval to change its name to First Baptist Church. A three-story Sunday school wing was added on the east side in 1949 by the Daniel Construction Co. for nearly $150,000. The further addition of a 39,000-square-foot educational wing was completed in 1957. The next momentous occasion came in 1974, when many in the burgeoning congregation moved to a new building on Cleveland Street. Another contingency stayed behind in the McBee Avenue building, which then became known as Downtown Baptist Church.

110 West McBee Avenue
Greenville, SC 29601

7. Lanneau-Norwood House

Charleston native Charles H. Lanneau came to the Upstate in the last quarter of the nineteenth century to serve as treasurer of the Reedy River Factory. He was a man of means and established himself in Greenville with the building around 1877 of one of the city's most beautiful mansions built to that time or since. The three-story brick home was built in the popular French Second Empire architectural style. American architects in the Victorian age were inspired by French architecture during the reign of Napoleon III. Lanneau's heritage was French, which probably contributed to his decision to identify himself and his home in this style.

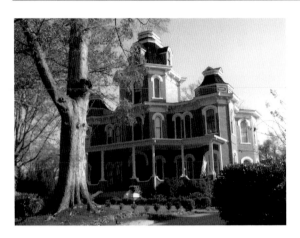

The Lanneau-Norwood House, built in the Second Empire style circa 1877, is one of Greenville's most impressive mansions.

The first and second stories of the home are identical in structure except for the enlarged doorway entrance. The façade is divided into five sections, with the center and corner three-sided bays projecting out. The second-story outer bays have single chamber-arched windows on the front, while the rest of the façade has semicircular arched windows (paired in the recesses on each floor). The first floor has a brick arcade wall with reverse chamber arches terminating at raised bases for the simple square posts supporting the porch overhang. The second floor is capped by a thick cornice with decorative trim and brackets. On the roofline, two short mansard roof towers rise above the corner bays. The impressive octagonal central tower rises a full story above the house to provide additional living space. The mansard roof on the central tower has dormers extending out from each side terminating in a three-tiered apex. Additional two-story windowed bays extend off the sides of the house to complete the pleasing undulation of the entire surface.

Several years after his home was built, Lanneau used his textile experience to partner with fellow Charlestonian Charles E. Graham to organize the Huguenot Mill on the banks of the Reedy River in downtown Greenville. Five years later, he left that mill to start his own mill near his home neighborhood. When Luther McBee started the Vardry Cotton Mills on the lower falls of the Reedy River, Lanneau became its secretary.

The next chapter in the house's story picks up with another prominent Greenville businessman. John Wilkins Norwood came to Greenville from Charleston around 1886. He started the Greenville Trust and Savings Co. in 1906 and reorganized it under his own name, Norwood National Bank, a year later with a capital stock of $125,000. It was in this same year (1907) that

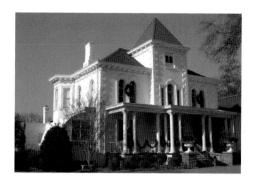

The William Wilkins House on Augusta Street is one of Greenville's grand Victorian homes.

Norwood, flush with earnings from his financial venture, bought the house and property from the Lanneau estate. Mrs. Norwood was against the purchase because she thought this "country house" was too far from the hustle and bustle of downtown Greenville. The home soon expanded with the addition of a kitchen and larger porch. John Norwood also became vice-president of the American Spinning Co. The home passed by inheritance to Mr. and Mrs. Sapp Funderbunk in 1945 and continues to remain in the family. Today the historic Lanneau-Norwood House stands as a superb example of the Second Empire style of the Victorian era and one of the most attractive homes in Greenville.

417 Belmont Avenue
Greenville, SC 29601

Traveling south on South Main Street, turn left on Broad Street and continue for half a mile. Take a slight right onto McDaniel Avenue and then a left turn onto Belmont Avenue. The Lanneau-Norwood House is at the top of the hill on the left side.

8. Efird's Department Store

For many years this late nineteenth-century building was occupied by Efird's Department Store, one of the many department stores that lined Greenville's Main Street until their mass exodus in the 1960s and '70s to relocate to the suburb malls. By that time the Dollar Store had taken over Efird's store and the entire brick building was painted bright white.

The three-story brick building reflects the tastes of the late Victorian era in which it was built (circa 1885). American architect Henry Hobson Richardson was primarily responsible for spreading a Romanesque Revival architectural style in the late nineteenth century. The dominant motifs of the semicircular arches and columns set the tone for the classical

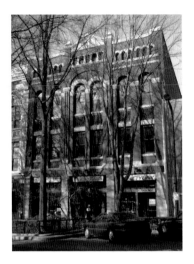

The old Efird's Department Store is one of downtown Greenville's oldest and most charming buildings.

nature of the entire building. The building is designed with three primary sections that divide the building vertically into thirds. The middle third of the façade projects forward farther than the rest and also rises up taller with the addition of a pediment. A short arcade runs across the entire top of the building. The central arcade features Doric baluster columns with no arches in between, while the right and left arcades have a series of keystone course arches ending in pilasters rather than columns. In the center a single blind arch spans the entire section, terminating in a clustered set of three engaged columns with germinated capitals. A keystone course double arch insets the blind arch with abutments above pilasters that run two stories down. A wider pair of arches in the left and right sections also terminates in two-story pilasters. Above the second-story windows is an attractive dogtooth course of bricks that add a nice complexity of texture to the overall façade.

Horizontal bands of rustic stone masonry accent the arcades at the top and windowsills, creating color and textural variety. On the street level, four large rusticated stonework columns border the three main sections of the structure. If you look closely, you'll notice the original tin tiles on the soffits above the doorways and also covering the tall ceiling inside the modern stores. Buildings like this are a great asset to Greenville's architectural variety and lend an irreplaceable level of charm to the downtown experience. More and more of these old buildings that line Main Street are being uncovered and restored as Greenville continues to embrace its past.

14–16 South Main Street
Greenville, SC 29601

9. Broad Margin

Of all the twentieth-century architects who have made important contributions to their field, Frank Lloyd Wright is at the top of the list. Greenville is privileged to have one of his

homes right in the vicinity of our downtown. Not only do we have a Frank Lloyd Wright home, but it is only one of two in the entire state (Auldbrass is the other) and one of nineteen homes that were ever "signed" by the architect with a plaque bearing his initials at the entrance.

The unlikely story of a Wright house in Greenville begins with two unassuming sisters, Charlcey and Gabrielle Austin, who lived quiet lives as a librarian and teacher. As they considered options for building their home, they decided to

Broad Margin, one of only two Frank Lloyd Wright homes in South Carolina, is an important historic example of American architecture.

go with an architect whose designs they really enjoyed—Frank Lloyd Wright. By then he was already established as America's leading architect, with such masterpieces as Falling Water and the Taliesin under his belt and the Guggenheim Museum on the horizon. According to a story in the *Easley Times*, despite the odds against them, they "just asked him and he did it." After just a few months the Austins had the plans in hand but faced the more difficult task of finding a builder willing to construct it. They tried in vain for three years to secure a builder until a wide-eyed thirty-one-year-old contractor from Easley, Harold Newton, submitted a bid at over half the cost of all previous offers. The ladies joyfully accepted and construction of the 1,727-square-foot home began in 1951.

Wright's name for the Austins' home, Broad Margin, derives from a quote from Henry David Thoreau's *Walden*: "I love a broad margin to my life." Typical of his architectural philosophy, Wright incorporates natural materials with an open plan that brings in the natural surroundings through the use of forty-eight-inch windows running continuously around three sides of the house. Natural fieldstones gathered from the surrounding property are embedded into exterior walls. The low-pitched roof with eight-foot overhangs extends out of the ground level of the northern side of the property as if it were a natural extension of it. Looking at the house from Avondale allows a view almost exclusively of the roof—part of the privacy element that Wright consciously worked into the overall plan.

The northeast corner main entrance leads to a central hallway, from which all rooms branch off. Natural sunlight bathes each room and tempers the red tidewater cypress–lined walls and ceilings installed entirely with brass screws (no nails are used in the entire house). The red concrete floors give a natural feel

throughout the house and are heated by embedded copper water pipes. Coming straight in (west) down the hallway, two steps lead up to a three-bedroom and two-bath wing extending from the main body. Directly left from the entrance is a large living room facing a park with a meandering creek on the property's south side. A centrally located massive stone hearth brings radiant heat and a comfortable feel to the living room. Wright also designed the original furniture, including a built-in couch, music credenza, two coffee tables, six living room and bedroom hassocks, two bedroom vanity desks, three bedroom dressers, three trashcans, two tabourets, a dining room set and side tables. All of the house's hardware is solid brass. Next to the living area facing south in the open plan is the dining room with an adjoining screened porch. The small kitchen is centrally located in the home (behind the hearth) with an eighteen-foot skylight that brings in plenty of natural lighting to the enclosed area. Other structures on the property include a carport, toolshed and tiered patio.

When the home was up for sale in 1975, it was listed in the classified ads along with all of the other "ordinary" homes. But this was no ordinary home, and when architect Roy Palmer saw it advertised for $68,000 he jumped on it. The Palmers enjoyed the home and let many visitors come and admire it. However, some original furniture was sold, including a tabouret for $27,500 in 1989. Three years later the entire home and contents were up for sale for $695,000 but it didn't sell. Finally, in 1997 Broad Margin was up for auction with a minimum bid of $250,000 and another $250,000 for the furniture. Inquiries came in from all over the globe. In the end, Frederick Bristol Jr. of Bristol-Myers Squibb Co. bought the house and furniture for $700,000.

One of the examples of the home's significance is found in its acceptance into the National Register of Historic Places in 1978. One of the primary stipulations for a structure to be considered for inclusion is that it be at least fifty years old. Because of the importance of Frank Lloyd Wright, the home's quality and its rarity in both South Carolina and the South in general, it was accepted into the Register twenty-six years (over half the amount) earlier than the requirement.

9 West Avondale Drive
Greenville, SC 29601

Traveling north from Court Square on Main Street, continue about one and a half miles and then turn left on Avondale Drive. Broad Margin is the second home on the left side.

Tour 5

Greenville's Art and Cultural Treasures

The "cultural campus" of the city is found at a site called Heritage Green in the northwest quadrant of downtown. The site is bordered by Academy Street and College Street, both of which were named for educational institutions previously located on the same site. Academy Street refers to the male and female academies that were chartered in 1820 and finished a few years later. They were the first "private" school buildings in the fledgling little village in an area (at that time) that was a good distance outside of the main part of town. The brick boys' school was located approximately where the Greenville Little Theater now stands and the larger girls' school stood on the land where the Children's Museum (former Main Library) and Greenville County Museum of Art now stand. Vardry McBee, the city's first great philanthropist, donated all thirty acres of the surrounding area to the schools.

When the Southern Baptist Convention was looking to locate a city for an all-women's school in the mid-nineteenth century, Greenville was their choice. Local leaders, including Vardry McBee, decided to seal the deal by allowing the Greenville Baptist Female College to use the old male and female academy buildings. The school opened in 1854 and eventually was absorbed into Furman University when it moved to its new campus on Poinsett Highway. The name of College Street comes from the long history of the Greenville Baptist Female (later Women's) College on the property.

Even though the previous four tours have concentrated on people, places and things important to Greenville's history, there are significant cultural institutions in Greenville that preserve artifacts from around the nation and world. The depth of history, quality of presentation and importance of objects preserved in these museums might make you think you are in a metropolitan city many times the size of Greenville.

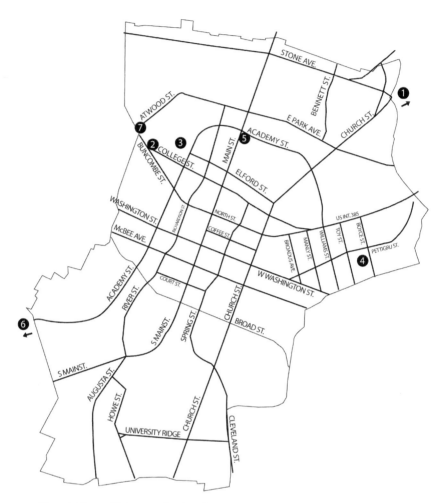

Tour 5: Greenville's art and cultural treasures.

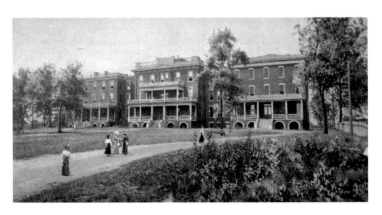

Greenville Baptist Female College began in 1854 on what is now the Heritage Green campus. *Courtesy of the Greenville County Library System.*

In the spirit of his early nineteenth-century predecessor, developer Phil Hughes donated land for the new museums and library on the Heritage Green campus.

1. Museum & Gallery at Bob Jones University

When the Museum & Gallery at Bob Jones University opened in 1951, it was Greenville's first public art museum. It is still the oldest continuously running museum in the city and is one of the most significant cultural assets in the entire South, making Greenville an international destination for the enjoyment of Old Master paintings. The collection began with 25 paintings spanning the fourteenth through eighteenth centuries displayed in a few rooms. Guests today often think that they will see a few rooms of paintings, but are pleasantly surprised to find nearly 450 Old Masters filling thirty rooms.

The holdings of Italian paintings are one of the most important in the country—only nine other museums have more (including the Met and the Walters). The first fourteen galleries are filled with Italian paintings spanning the Gothic through the Rococo periods. Botticelli's *Madonna and Child with an Angel* is hung in an octagonal room filled with tondo (round) paintings—a unique arrangement that highlights seven out of the museum's nine paintings in this popular Renaissance format. From the Italian Mannerist period, Giovanni Antonio Bazzi's masterpiece is found, along with an early Tintoretto of *The Visit of the Queen of Sheba to Solomon*. The heart of the collection is found in the Italian Baroque (seventeenth-century) period spanning an unbelievable six full rooms (only three American museums have more Italian Baroque paintings). Highlights include Guido Reni's four evangelists, *Matthew, Mark, Luke and John* (the original and only complete set existing); a signed altarpiece by Giovanni Baglioni; Giambattista Tiepolo's *Philosopher*; Luca Giordano's monumental *Christ Cleansing the Temple*; and Domenichino's *St. John the Evangelist*.

The second half of the museum features masterworks from Spain, France, England, the Netherlands, Belgium and Germany. From Spain, works range from a fifteenth-century full retable dedicated to St. Lucy and Juan de Juanes's impeccable *Pentecost* to later works by Pedro Machuca, Francisco de Herrera the Elder, Bartolome Esteban Murillo and Jusepe de Ribera's signed and dated *Ecce Homo*. Moving on to the French gallery gives a sweeping view of the Baroque, with works like Trophime Bigot's deeply Caravaggesque *St. Sebastian Tended by Irene*, Jacques Stella's dreamy *Adoration of the Shepherds*, Sébastien Bourdon's classical landscape of *The Hiding of Moses* and Charles Le Brun's

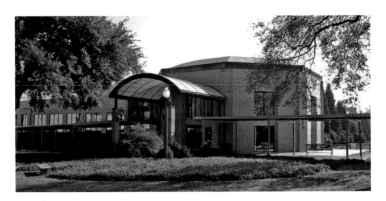

The Museum & Gallery at Bob Jones University, Greenville's first public art museum, has hundreds of Old Master paintings from the fourteenth through the nineteenth centuries.

polished modello of the *Pentecost* (complete with a self-portrait of the artist). Later French masters include Gustave Doré (two works) and Felix Louis Leullier.

The survey of Flemish and Dutch artwork is remarkable for its depth and quality. Works by the earliest Renaissance masters such as Rogier van der Weyden, Gerard David and Colijn de Coter give context for the developments by Northern mannerists like Jan van Scorel, Hans von Aachen and Cornelis Cornelisz van Haarlem. Two full rooms are dedicated to Flemish Baroque paintings, including Peter Paul Rubens (two), Anthony van Dyck (two) and more works by Johann Boeckhorst (four) than any museum in the country. Two Dutch Baroque rooms showcase works by Rembrandt's students and closest followers (including a modello by Govaert Flinck used to beat Rembrandt and others for the commission of Amsterdam's Town Hall) and the other with Utrecht's "candlelight masters" like Honthorst, Terbrugghen and Bijlert (the Museum & Gallery has more Northern Caravaggisti paintings than any in the nation).

A sampling from the German school includes three works by Lucas Cranach and more by Jorg Breu, Master of St. Severin and Ary Scheffer. Impressive English works are seen in Eyre Crowe's academic *Martin Luther Nailing His Theses to the Doors of Wittenberg* and Edwin Long's Orientalist masterpiece, *Vashti*. The museum's collection of nearly fifty Russian and Greek icons dating from the fifteenth through the twentieth centuries brings in a perspective of Eastern European painting found in only a few North American museums. Five of these works were formerly owned by members of the Romanov royal family. Beyond the paintings, the museum also displays European sculpture, stained-glass windows, period furniture, decorative arts and period architectural room elements.

Not only are highlights of Western European painting since the Gothic period shown, but the collection reaches five thousand years back into history with a nice representative collection of about one thousand antiquities. Amulets, scarabs, a canopic jar, shwabti figures and a false door stele are some of the many Egyptian items on display—all excavated by the great English archaeologist Sir Flinders Petrie. Hebrew artifacts include an ossuary, child's baby rattle (circa 1200 BC), a 121-foot fifteenth-century Torah scroll and a cuneiform tablet dictated by King Nebuchadnezzar. Roman antiquities from the time of Christ's life on earth include a "widow's mite," Roman dice and an array of handheld oil lamps.

Other cultural highlights to be found on the university campus are the series of seven paintings by Benjamin West painted for King George III's private chapel at Windsor Castle and the "Jerusalem Chamber" in Mack Library, which is a reproduction of the room in Westminster Abbey where the original King James Bible was translated. Many ancient Bibles and manuscripts are on display in this room.

The artistic and cultural assets found in the Museum & Gallery at Bob Jones University contribute significantly to Greenville's position as one of the South's leading artistic centers.

1700 Wade Hampton Boulevard
Greenville, SC 29614
www.bjumg.org

From North Main Street, turn right on Academy Street and go straight. Next turn left onto Church Street and go straight until you reach the Wade Hampton Boulevard intersection; turn right. Continue up Wade Hampton Boulevard for one mile and take a right into the main entrance of Bob Jones University campus. Street signs on campus will direct you to the museum's parking lot.

2. Museum & Gallery at Heritage Green

According to Choice McCoin, Coca-Cola established a presence in Greenville around 1902. Around 1925, the company bottled and distributed soda out of a brick building at 665 South Main Street before building and moving into the present building around 1930. It was built in the Italianate style by Morris-McKoy Construction, with attractive brickwork and decorative corbels around the perimeter of the roof overhang.

The historic building is now the most recent art museum in Greenville's growing repertoire of cultural attractions. While the Museum & Gallery at Bob Jones University has served

The Museum & Gallery at Heritage Green brings European masterworks to downtown Greenville in a restored 1930 Coca-Cola Bottling Co. headquarters.

the community longer than any other, the establishment of its satellite museum in the heart of downtown's cultural campus brings the important dimension of European Old Masters to the mix. Rather than housing a permanent collection, this entire space features rotating exhibits under thematic displays primarily from the Museum & Gallery's deep resources but also borrowed from private and public collections. The first floor is the exhibition space for artwork, while the second level is entirely dedicated to in-depth educational displays that expand on the exhibition theme from the first floor. A dedicated room for children stimulates learning through interactive displays and unique technological applications.

516 Buncombe Street
Greenville, SC 29601

3. Greenville County Museum of Art

The Greenville County Museum of Art officially began in 1963 as an outgrowth of several local art organizations that had been displaying art for decades before. The first building to house the collection was the extravagant Gassaway Mansion on Dupont Drive. After about a decade in the old building, a new structure was needed to properly attract and host traveling exhibits.

The Greenville County Museum of Art is a treasure-trove of American art, with particular strengths in works by Andrew Wyeth and Jasper Johns.

In 1974, an eighty-thousand-square-foot modern building was completed at Heritage Green, due primarily to generous funding by Greenville County and the Magill family. Arthur and Holly Magill not only were the impetus behind getting the museum built, but they also brought the museum national attention with the long-term loan of several hundred works by Andrew Wyeth, making the Greenville Museum the largest repository of his works outside of his hometown in Pennsylvania.

The driving force behind the museum's focus and direction came when Tom Styron took over as director in 1983. Under Styron, the museum was a pioneer in the formation of a comprehensive survey of American art, using Southern-related examples from colonial days to the present. The earliest work predates Greenville's settlement by over forty years, with a pastel portrait (1726) by America's first female professional artist, Henrietta Dering Johnston from Charleston. Other notable early American painters represented include Washington Allston and Thomas Sully. Joshua Shaw's circa 1820 painting of *The View on the Reedy River* (purchased in 2008) shows the earliest known view of both Greenville and its falls. Charles Fraser's Harnett-like *Still-Life* is a remarkably facile trompe l'oeil of game birds—painted nearly half a century before the genre became wildly popular in America. Of the early American portraits, George Healy's important *Portrait of John C. Calhoun* is a reminder of the former vice president who used to come

to Greenville, stay at the Mansion House and speak on current issues to our local citizens. John Ross Key's historical document of the *Bombardment of Fort Sumter* especially resonates with South Carolinians interested in Civil War history. Other not-to-miss paintings are Thomas S. Noble's indelibly profound scene of slaves as *Fugitives in Flight* and Martin Johnson Heade's haunting landscape *On the San Sebastian*.

Masterworks continue into the twentieth century, with works ranging from artists who taught in the South (Georgia O'Keeffe, Josef Albers and George Bellows), were born in the South (Elliott Dangerfield and William Henry Johnson), worked in the South or drew inspiration from its subject matter (Arshile Gorky and Philip Guston). Notwithstanding the power of its survey of Southern art in general, perhaps the most significant strengths of the museum are its impressive surveys of two of America's greatest living painters—Andrew Wyeth and Jasper Johns. Wyeth's remarkable paintings, including many drybrush watercolors, represent every major phase of his long career. With over fifty works by Jasper Johns, the museum is one of the premier public collections of these two artists in the United States and certainly the best in the South. The museum also holds an unusually large trove of works by Stephen Scott Young, a watercolorist whose profound paintings of African American genre scenes carry on the spirit of Wyeth.

World-class loan exhibitions are brought to Greenville's doorstep through the museum's active programming in a variety of intimate, medium-sized and expansive spaces. America's artistic heritage is shared with the community through an active educational outreach, while its in-house art school trains up-and-coming artists. With such artistic and educational resources, the Greenville County Museum of Art is one of the Southeast's leading American art collections.

420 College Street
Greenville SC 29601
www.greenvillemuseum.org

4. Museum and Library of Confederate History

The presence of the Sixteenth Regiment, South Carolina Volunteer's Museum and Library of Confederate History establishes an important component to the overall cultural offerings of Greenville. It was established in 1996 under the committed vision of a local lawyer and Confederate history buff, Vance Drawdy. The museum is situated in the Pettigru Historic District, once the property of James Petigru Boyce, first president

The Museum and Library of Confederate History provides a rich American history of the era surrounding 1861–65 through its displays, artifacts, educational outreach and reenactment activities.

of the Southern Baptist Theological Seminary. Interestingly, the first building in the area (east of Christ Church Episcopal) was the home of the Greenville Military Institute (1878–87), situated slightly west of where the Confederate Museum now resides.

Though the current building is small and retrofitted, the displays inside are diverse and represent a broad view of the artifacts and culture surrounding the period of 1861–65. The War Between the States (commonly known as the Civil War) was one of, if not the, greatest turning points in American history. The museum seeks to educate the community about the significance of the people, politics, social context and remaining artifacts involved in this area.

Upon entering, the main room is filled primarily with a myriad of weapons from the mid- to late 1800s. Of particular regional interest is a case of guns and swords made in Columbia at the Palmetto Armory, whose ironwork business was converted during the war to produce much-needed weapons. There is even an example of a prewar manhole cover the foundry produced before it was enlisted for battle purposes. Also on view is an example of the Morse breechloading carbine rifle, a war gun made right here in Greenville at the State Military Works. The facility was located on Green Avenue in the West End on land donated by Vardry McBee and produced guns exclusively for South Carolina militia. This advanced machine was ahead of its time and is one of about a thousand that were produced. Gun

inventor George W. Morse was the nephew of Samuel Morse, inventor of the telegraph and Morse code. His rifle, produced primarily in Greenville, has the distinction of being the first gun to use self-contained centerfire bullets. Modern-day bullets all use this firing system, which originated with the machinery in Greenville's State Military Works (brought here from Harpers Ferry, West Virginia). The other gun produced in Greenville was Morse's musket, which held his innovative internal lock. The .71-caliber muskets were all marked with "Morse's Lock, State Works, Greenville S.C." Scores of other rifles on display give context to the type of weapons that were used by Union and Confederate soldiers before, during and after the war.

Among the other displays in the main room include a section dedicated to the famous Hunley submarine and understanding its development and role in the war. Above this is an original example of the first national flag ("Stars and Bars") of the Confederate States of America, which was captured in the Battle of Atlanta. A series of photographic reproductions honors all of the South Carolina generals who served, including S.R. Gist. The soldier's father was so passionate about the Southern cause that he named one son Constitution (first name) and the other son (who became a general) States (first name) Rights (middle name).

The small Documents and Currency Room shows examples of money produced during the war, with many variations of the Confederate currency. There is even an example of a Union counterfeit next to the same (real) Confederate note that reveals one of the tactics used by the North to devalue Southern money.

A recent source of the collection's pride is the donation of a circa 1861 (possibly earlier) grand piano handcrafted by the Gilbert Piano Company in Boston. The piano features an unusual combination with melodeon (pump organ). It was ordered by the Brannon family of Charleston in the midst of the war and circumvented a Union sea blockade in transit to its destination. Privately donated funds allowed a recent full restoration for the instrument.

Perhaps the most important artifact on display is an original copy of the South Carolina Ordinance of Secession, signed by all members of the Secession Convention of the State of South Carolina on December 20, 1860. While it is not the original document, it is a period lithograph copy. After the original was signed, two hundred lithograph copies were given out to signers and other important South Carolinians. The example here is one of only a handful left existing in South Carolina collections.

15 Boyce Avenue
Greenville, SC 29601
www.confederatemuseum.org

5. American Legion War Museum

The American Legion's stone building was erected for the organization in 1934 and has served as a meeting and activity center ever since. Under the leadership of Cecil Buchanan, the Legion started a public museum in the building in 2002. Though there were just a few objects at first, the museum has grown leaps and bounds through donations and loans, primarily from veterans and their heirs. Fascinating war artifacts from every major American conflict are represented, giving honor to those who have served our country.

Displays line the exterior walls grouped in cases mostly themed by specific wars. Examples of guns used in battle range from several Revolutionary War rifles all the way through machine guns from the Vietnam War. From the Spanish-American War visitors can see original war letters, photographs and buttons. The real highlight is a book of sheet music signed by Theodore Roosevelt. Dozens of authentic uniforms from the Civil War through an Operation Freedom flight suit give a remarkable survey of the evolution of styles used by servicemen. One of the most important items in the collection is an 1861 Confederate cap originally made in Columbia and worn by a Greenville County lieutenant from the Fourth Regiment of South Carolina Volunteers. The soldier was struck in the head by a bullet in the Battle of First Manassas in Virginia on July 21, 1861, and died

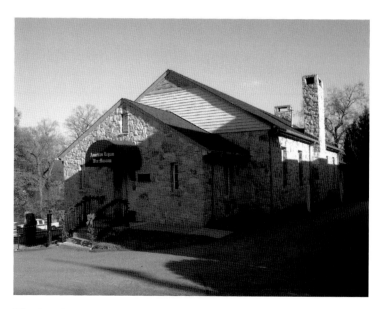

The American Legion War Museum gives fascinating insights into all of America's major wars.

five days later. Other items of interest include examples of the first handheld walkie-talkies used in war (World War II) and a soccer ball like those given to Iraqi children by U.S. soldiers in the aftermath of recent conflicts.

Besides war-themed displays, a number of others are especially focused on subjects with Greenville connections. A case with items telling the story of Major Rudy Anderson's heroic story includes examples of all the medals he received and a copy of the letter President John F. Kennedy wrote to his mother after he was shot down during the Cuban missile crisis. Large photos and maps of Greenville's World War I Camp Sevier give a sense of the massive installation that once filled the area beyond present-day Wade Hampton Boulevard and Pleasantburg Drive. Greenville's surprising role in readying supplies for D-day and in Doolittle's flight to Japan are also revealed.

Perhaps the most memorable part of your visit may be the helpful volunteer veterans who greet you and gladly describe displays for visitors. Their personal stories are just as colorful as the uniforms they wear, such as Roland Sluder's tales of his days as one of General George Patton's bodyguards and nights spent in Goering's home after the war. The museum's library is also available for further learning.

430 North Main Street
Greenville, SC 29601
www.americanlegion3warmuseum.com

6. Greenville Cultural Exchange Center

"Without vision the people shall perish." These profound words of scripture apply to the vision of a woman who has kept African American history in Greenville alive. Ruth Ann Butler grew up in the civil rights era of Greenville and knows that part of Greenville's history all too well. She attended Sterling High School, Greenville's first African American secondary school and one of its most significant institutions for educating and developing African American leaders on many levels.

After working as a schoolteacher for the Greenville County school system for many years, Butler's love of history led her to assign her students a project to study their family genealogy. Butler then became interested in finding out more about her own family's history, as Betty Solomon relates in a *Greenville News* story interview. The results inspired Butler to take on a larger project of organizing the first Butler family reunion, reuniting hundreds of people from around the nation. A visit to the Beck Cultural Exchange Center in her sister's hometown

The Greenville Cultural Exchange Center serves a vital role in preserving local African American history.

of Knoxville, Tennessee, provided the spark for Butler's next project, which would draw nationwide attention far beyond the Butler family. Ruth Ann took Knoxville's model and sought to create a resource for Greenvillians to preserve and educate others about its neglected yet significant African American history.

The center received tax-exempt status and seed money from the city and county councils in the mid-1980s, and plans went forward under Ruth Ann's tenacious leadership to make her dream a reality. Through private donations, a Victorian-era house was purchased and the center officially opened its doors for the first time on August 22, 1987.

As the only repository of its kind, the Cultural Exchange is a vital repository for preserving Greenville's unique African American history. Since it was only started in 1987, much of the city's oral histories and artifacts have been lost over the centuries since the first African Americans came as slaves of Greenville's pioneer colonial settler, Richard Pearis, around 1769. African American history in the city is as old as Caucasian history, and the Greenville Cultural Exchange Center is dedicated to preserving as much of what remains as it can. Changing displays present various educational themes with information, photographs and artifacts that provide insights of Greenville's African American history that have never been presented before. Furthermore, hundreds of books and photographs at the center serve as a research center for school groups, adults and scholars alike.

Some of the interesting historical items to find at the museum today include the entire set of yearbooks from Sterling High School—a rare commodity since the school burned down in a 1967 fire and closed for good three years later. Perhaps the most distant and frequent requests the center receives is for information about Greenville's internationally known African

American leader, Reverend Jesse Jackson, who grew up just a few blocks from here. A particularly unique item is a life-size painted torso of the civil rights leader cast from Jackson himself. A tangible part of his history in Greenville is a bellhop uniform he wore when working at the downtown Poinsett Hotel. An old dentist's chair, instruments and diary are preserved from one of Greenville's early African American dentists, Dr. J. Guy Douglas. The original "peg" from the renowned tap dancer (and Fountain Inn native) Peg-Leg Bates's leg is also on display at the center. He lost his leg in a farming accident but his vision for greatness propelled him to eventually perform for the king and queen of England.

Overcoming difficult odds has been a hallmark of Ruth Ann Butler's experience with the Cultural Exchange Center—from locating operational funds and fighting artifact deterioration to acquiring items and managing the information and displays on an ongoing basis. The most difficult time since its founding was the forced closing of the center on May 25, 2001, due to structural instability and fire code violations. Butler and others rallied the support and funds of locals to open its doors once again in 2002. Sustained determination and hope in the vision of Ruth Ann Butler will carry this cultural center into even greater impact for years to come.

700 Arlington Avenue
Greenville, SC 29601
http://www.greatergreenville.com/visitors/cultural_exchange.asp

Traveling north on Main Street from Court Square, turn left on McBee Avenue and another left onto Academy Street. Continue on Academy for one mile and turn left on Pendleton Street. Take a quick right on Sumner Street and the museum is on the corner of Arlington Avenue.

7. Upcountry History Museum

Even before the downturn in the regional textile industry, concerted efforts were made to establish a textile museum in Greenville to commemorate its historic role in the city's growth and influence. Early attempts included a plan to turn the original Textile Hall into a museum, while later ideas turned toward dedicating a portion of the Peace Center complex to the cause in the late 1980s. The Historic Greenville Foundation (established in 1983) began in earnest in 1991 to make the museum a reality. After a decade of planning and fundraising, the $13 million building began in 2001 and finished in 2004.

Three more years of raising support led to its inaugural opening in September 2007.

The building's forty-five-thousand-square-foot space over multiple stories provides an expansive area for learning about Upcountry South Carolina history. Upon entering, the museum's unique approach to learning is immediately realized through the grand façades of Greenville's historic buildings. Entering into the First National Bank takes you to an auditorium (complete with touches of the Main Street bank's art deco flavor) with an orientation film summarizing facets of Upcountry life. Coming out to the left brings you past a lifelike portrayal of a colonial herder driving hogs down "Main Street" to a section that covers the frontier days. A few Native American artifacts (including a projectile point and an axe head) and a fiber-optic, interactive map are a few things that help visitors to sense the origins of civilization in the region. Additional first-floor themes are indicated by historic vignettes and façades. A church entrance leads to a dynamic video presentation (including pew seating) of the role faith has played in shaping Upcountry communities. A talking mannequin of Vardry McBee, one of Greenville's greatest businessmen, gives a sense of his character and the issues mid-nineteenth-century locals faced. A backdrop vignette of his general store displays railroad and clothing artifacts from the period. An adjacent diorama of early settlers describe issues of slavery and everyday life, even displaying an authentic

The Upcountry History Museum presents dynamic displays about Greenville's history within the context of the region.

nineteenth-century wagon made at Greenville's Gower, Cox and Markley Carriage Factory. Changing exhibits are found behind the Mansion House façade.

Going up to the second floor gives a great sense of nostalgia as you ascend the sweeping staircase of the three-story impression of the Greenville County Courthouse, designed by Robert Mills in the early 1820s. Within the mill display are vignettes of textile production with vintage looms and motion-activated audio explanations. Among the other exhibits, visitors can gain insights into the role of Greenville's military installations (housed within a tent) and also significant developments in the civil rights movement. The total experience will leave you with a thorough working knowledge of the Upcountry's historical highlights and its people. The abundance of interactive displays and applications of technology make the experience unique, fun and educational.

This long-awaited museum provides a key component to the overall cultural offerings found in Greenville. Its dynamic displays and plans for expansion (especially in the preservation of local oral histories) will keep you coming back to learn more.

540 Buncombe Street
Greenville, SC 29601
www.upcountryhistory.org

Bibliography

Albaugh, William A., III, and Edward N. Simmons. *Confederate Arms*. Wilmington, NC: Broadfoot Publishing Co., 1993.

Bainbridge, Judith. *Academy and College: The History of the Woman's College of Furman University*. Macon, GA: Mercer University Press, 2001.

——. *Greenville County Courthouse*. Brochure for Design Strategies, 2003.

——. *Greenville's Heritage*. Greenville, SC: J & B Publications, 2006.

——. "Greenville's National Bank: A Brief History." Pamphlet, Greenville, SC: Carolina First Bank, 1988.

——. *Greenville's West End*. Greenville, SC: Westend Association, 1993.

Barnes, Frank. *The Greenville Story*. 1956.

Belcher, Ray. *Greenville County, South Carolina: From Cotton Fields to Textile Center of the World*. Charleston, SC: The History Press, 2006.

Browning, William D., Jr. *Firefighting in Greenville 1840–1990*. Greenville, SC: Southern Historical Press, Inc., 1991.

Butler, Ruth Ann. *Sterling High School, Bless Her Name! 1896–1970*. Greenville, SC, 1993.

Cooper, Nancy Vance Ashmore. *Greenville: Woven from the Past.* American Historical Press, 2000.

Daniel, Robert N. *A Century of Progress Being the History of the First Baptist Church, Greenville, SC.* Greenville, SC: First Baptist Church, 1957.

Greenville News.

Huff, A.V. *Greenville: The History of the City and County in the South Carolina Piedmont.* Columbia: University of South Carolina Press, 1995.

Hunt, William Dudley, Jr. *Encyclopedia of American Architecture.* New York: McGraw-Hill Book Co., 1980.

Kitchen, Raymond W. *Way Down Beside the Reedy River.* Duluth, GA: United Writers Press, Inc., 2004.

McKoy, Henry B. *Greenville, S.C. as seen through the eyes of Henry Bacon McKoy: Facts and Memories.* Greenville, SC, 1989.

Murray, James W., and Dorcas B. Lindsay. *One Hundred Fifty Years: First Presbyterian Church.* Greenville, SC: The Sesquicentennial Committee of the First Presbyterian Church, 1998.

Ravenel, Beatrice St. Julien. *Architects of Charleston.* Columbia: University of South Carolina Press, 1992.

Richardson, James M. *History of Greenville County, South Carolina: Narrative and Biographical.* Spartanburg, SC: The Reprint Company, Publishers, 1980.

Robinson-Simpson, Leola Clement. *Black America Series: Greenville County, South Carolina.* Charleston, SC: Arcadia Publishing, 2007.

Tollison, Courtney L. *Furman University.* Charleston, SC: Arcadia Publishing, 2004.

Ward, Lucile Parrish. *God's Little Acre on Main Street: Springwood Cemetery.* Greenville, SC: A Press, 2003.

Willis, Jeffrey R. *Remembering Greenville: Photographs from the Coxe Collection.* Charleston, SC: Arcadia Publishing, 2003.

About the Author

J ohn Nolan grew up in Toledo, Ohio, and attended Bowling Green State University to earn a bachelor's of fine arts in painting and drawing with a minor in history. After further studio art studies at the Chautauqua Institution in New York and a summer studying art history in Florence, Italy, he came to Greenville in 1992 to earn a master's in studio art at Bob Jones University. Since 1997, Nolan has served as the curator of the Museum & Gallery at Bob Jones University. The combination of his research and tour giving experience at the Museum & Gallery and his love of history and for the city of Greenville led to the establishment of Greenville History Tours in 2006. The present guide is an outgrowth of the author's desire to share Greenville's rich history with the growing number of people who come to enjoy the ambiance and offerings found in its downtown.

John Nolan gives a Greenville history tour.

To find more about downtown Greenville walking, driving and trolley tours, contact:

John M. Nolan, owner
Greenville History Tours
864.567.3940
www.greenvillehistorytours.com